LIFE OF JESUS IN ICONS
FROM THE "BIBLE OF TBILISI"

With Commentary by
Francis J. Moloney, SDB

LITURGICAL PRESS
Collegeville, Minnesota

www.litpress.org

AUTHOR/TRANSLATOR'S NOTE

The Preface from Bishop Giuseppe Pasotto has been translated into English while the Italian introduction to iconography by Fr Gabriel Bragantini that opened the original book has been rewritten for an English-speaking readership. The biblical text that accompanies each icon is the New Revised Standard Version, used with permission. The biblical commentaries on the icons were written in English for this publication. The reflections from the Patristic Tradition are generally based upon published translations of these texts. Most have been reworked slightly, with reference to the original Greek and Latin, to respond to a modern readership. In a few instances the Patristic texts provided in the original Italian have been translated into English. The translations of these ancient texts attempt to reflect the life and spirituality of the Early Church, rather than the English of the third millennium.

Francis J. Moloney, SDB

CONTENTS

PREFACE

When love enters time, history is made and ... the events of history become life-giving.

It is always fascinating and surprising when we reach beyond the events of history to find the thread of love that holds them together. This thread is surprising and fascinating because we become aware that the story of love is the story of the mystery of God. But in history as we know it, it is also the story of the mystery of human experience.

To open the Bible is to be gifted, graced, with entry into this two-fold mystery.

In all times and places the Church has opened the Bible and proclaimed it, publicly in the Liturgy and privately in homes where reading the Bible takes place. However, especially in Eastern Christianity, the Church has opened the Bible for proclamation in another equally beautiful and understandable form, in public and in private, through the eloquent language of the icon. Every icon is an announcement of the mystery of love. An icon attempts to translate a page of the Bible into the language of beauty. Such a translation can only be achieved by someone who has been intimately touched by this mystery.

In the Cathedral Church of Mary of the Assumption in Tbilisi (Georgia) "the Word of Life" is solemnly opened up in the Liturgy, but it is also told through one hundred and thirty icons of scenes from the Old and New Testaments, elegantly arranged along the Cathedral's side walls.

Beyond their didactic and artistic effect, the icons uncover for the faithful the thread of love that can draw them to enter, through prayer, into contemplation of the image of the invisible God.

The Catholic Church present in Georgia wishes to become a bridge between the Churches of the East and the West. It hopes to witness to the richness of the sacred Tradition of the universal Church, a

wonderful treasure to be known and valued by "giving thanks to the Father, who has qualified us to share in the inheritance of the saints in light" (*Col* 1:12).

I pray that as you turn the pages of this book, or maybe one day come to visit our Church in Tbilisi where the icons are gathered, you will be able to perceive the divine Presence who gazes upon you and who calls you by name, who loves you and seeks to transform you.

✠ *Giuseppe Pasotto*
Apostolic Administrator of the Caucusus for the Latins

INTRODUCTION

The presentation of the icons and the commentary that follows reflect upon the mystery of Jesus, Son of God. By becoming a human being he became completely available. He allowed himself to be heard, seen, contemplated and touched (see *1 John* 1:1-4). Brief reflections on the role of the icon in the Bible, the use of the Bible by the creators of the icons found in the Catholic Church in Tbilisi, Georgia, the iconic presentation of Jesus Christ and his Mother, the icon in tradition, and the icon in the Liturgy occupy these introductory pages. They may be of use to some who are approaching icons for the first time.

The icon in the Bible

Creation is an icon. It is a work of God and, however ambiguous the world might be, it manifests the grandeur of God. This can also be said of the Bible. It can be regarded as an icon because it is a product of an encounter between God and human beings that led to telling the story of God's action in human words. It is possible to read the Bible to learn things, to come to understand the past, to recapture the imagination of the original writers. But an authentic reading of the Bible must do more than that. As the believing reader learns things, understands the past and recaptures the imagination of the original authors, something more profound takes place. The authentic Christian reader comes to experience the presence of God and the risen Lord in and through a faith-filled reading of the Bible.

In recent times there has been an increasing interest in the Bible, and also in the icon. Perhaps it might be helpful to show the intimate link that exists between the Bible and the icon, between the written word of the Bible and the imaged word of the icon. The Bible is a book composed of many books, revealing a rich diversity, and even many imperfections, because these books are "the Word of God written in the words of men and women." The use of icons to represent the great biblical stories and characters draws much of this diversity into a more harmonious unity. The practice of iconography, marked by a

unified style, the rich use of colour in depicting people and places, and especially the ever-present golden background, forms a single testament of what we call the Old Testament and the New Testament. They tell of one covenant: the new and eternal covenant in Jesus' blood poured out for us in the fullness of time (see *Matt* 26:28).

The icon in the "Bible of Tbilisi"

The events and personalities of the Bible have been made visible through iconography across almost the whole of the history of Christianity, even though there have been times when the practice has created tensions and even schism. However, even in the darkest and most difficult moments, a trembling hand has desired to represent a prayer, an invocation, a scene, or a face, by means of a figure on a wall, on a piece of wood or iron, or on a cloth. These profound movements of the human spirit, themselves an indication of the presence of the divine within the human, tell us that the icon is not the product of the hand of an artist, but the heart of a believer. Icons are not an end in themselves, designed, painted or carved to establish the fame of the artist. They exist to serve the Word of the Gospel.

Over the centuries, every tiny space of the walls of many Churches were transfigured into pages full of the Word, not primarily to teach, but to create images, and then to proclaim and make visible the Word of God. By means of the icon, the Church dressed itself in light and colour for a festival because it is the body of Christ, not built of ordinary stones, but of living stones. The most beautiful events that can be depicted for the believer are the mighty works that God has done for us. Before an icon the believer "sees and hears" the mighty works of God. A building becomes a hymn to God, but also a petition that the Church might become that which it should be: a mirror that reflects the glory of God. For those who are "outside," from whom the mystery of the Kingdom is hidden, this is nonsense. For those who are "inside," it is to experience the sacred (see *Mark* 4:11).

The more one immerses oneself in the Bible, the more one will be able to create an icon that is "always new and always ancient." Only regular attention to the Bible will make us aware of the never-ending biblical details that the icon renders full of meaning. A loving

closeness to the Word of God in the Bible is necessary for the world of iconography to speak to the world of today. Paraphrasing a phrase of Saint Jerome, we can say that ignorance of the Scriptures is ignorance of the icon, and vice-versa. The world of the icon explodes into life when there is a profound knowledge of the Bible. When the Bible and the iconographic representation of the Bible are separated from one another, we finish with *sola Scriptura* on the one hand, or *sola Traditio* on the other. As the history of the Church and its teaching have shown, Sacred Scripture and Sacred Tradition belong together. Their separation has always led to misunderstanding and frustration among the Lord's faithful, powerfully so in the sixteenth and seventeenth Christian centuries in the Reformation and the Counter Reformation in Europe.

Icons attempt to lead the believer to a closer encounter with the Redeemer. We must allow ourselves to be caught up in the mystery of light that is found in them. It is not important to understand or to know everything, but we must not lose the horizon always provided by the golden background that links together all icons. The pages that follow present an iconic "Life of Jesus," an attempt to make the Word better known.

The icon of the Lord Jesus

Jesus of Nazareth provided a face that one could see, describe, picture, a voice that emerged from an identifiable face. "My sheep hear my voice and they follow me" (see *John* 10:4), because the voice cannot be separated from the one who spoke, from the face of the one who spoke it. When the shepherd will be taken away from them, then they will be scattered and the wolves will descend upon them to ravage them. The face and the voice render the person of Jesus present, they make "following" possible. It is not mere chance that the first visual images that we have of Jesus represent him as the shepherd. He is the one who gives life, who pours out his life for his sheep, who guides with his presence made up of words, glances, gestures and touch. In the face of the shepherd you can see the face "not made with human hands" of the Master. The sheep without a shepherd who go to Jesus, who gather around him and follow him experience a real presence,

11

an authority not like that of the Scribes and the Pharisees (see *Mark* 1:22). The Twelve chosen by Jesus remain with him and can "see" where he lives and how he lives (see *John* 1:39).

An eloquent glance like a double-edged sword penetrated the hearts of those first disciples and transformed them into fishers of human beings (see *Mark* 1:16-20). It was the same glance that restored them after sin, and it is to this all-knowing gaze that they entrusted their love, responding to the human love of Jesus, the incarnation of the divine love of God.

What would the Gospel be without the face of Jesus? The incarnation frees the Word from its lack of fleshliness: "And the Word became flesh and we have seen it and we bear witness to it" (see *John* 1:14; *1 John* 1:1-4). The incarnation opens up limitless space for human freedom. As we stand before his icon, consider for a moment words that come from the lips and heart of Jesus: "You will love the Lord your God … and your neighbour as yourself" (*Mark* 12:30-31). This is the moment when the exclamation, "no one has ever spoken like this" (*John* 7:46) might become true for us.

The Son will set us free to love God with all our heart and our neighbour as ourselves: that Son and not another, that face and not another, that Word and not another. God has taken on a face to love us with his whole being in and through the face of his Son: "who sees me sees the Father" (*John* 14:9). Only when God has spoken and has begun to transmit his Word has God become visible and able to transmit his image. As Holy Scripture begins with the revelation of God, iconography begins with the incarnation of God.

The icon of the Mother of God

"In the fullness of time, when God sent his Son born of a woman, born under the Law" (*Gal* 4:4), the Son received his flesh from her. This role is made present to us in the icon of the Mother of God. The incarnation of God in Jesus of Nazareth continues everywhere, from the "fullness of time" onward, until such time when we will see him and we will dwell with him. Mary, the servant of the Lord, pierced by the sword of the Word, always carries with her the Son of God who

took flesh and a face from her. We notice that in the icons the face of Jesus has the characteristics of the face of Mary.

But Mary is great not only because of the one to whom she gave birth, but also in herself because of the vocation of her motherhood of the disciple and her motherhood of the Church itself. The Mother of God is the mother of the disciple whom Jesus loved (see *John* 19:25-27). When Jesus exclaims "Behold your mother," her role seems to expand beyond the limits of any single generation. The motherhood of Mary seeks in everyone and in all times and places the response that Jesus perceived in his Mother: to hear the word of God and to live by it (see *Luke* 11:27-28). Mary, the Mother of Jesus, like her Son, had only one desire: the fulfilment of God's will.

We can thus call the icon of the Mother of God the icon of the will of God realised in Mary, just as it was in Jesus. But openness to the word of God and a willingness to believe in it continues to be realised in all those who have become Jesus' "brother, sister and mother" (see Mark 3:35). In the icon of the Mother of Jesus we are invited into the possibility of entering the glances that the Mother and the Son share with one another. This glance holds them together in a relationship of Mother and Son. The mutual gaze between the Mother and the Son dominates all iconography of Mary. The believer is asked to be drawn into their truth.

In the icon of the Mother of God there are two faces: the new Eve and the New Adam. Their mutual glances meet in the peace of those who know how to do only that which is pleasing to God: that which the first Adam and the first Eve did not succeed in doing. It has now been achieved in Jesus and Mary. Mary presents us with her Son, he who has made the fulfilment of the will of God his "food" (see *John* 4:34). In holding him before us she continues to say: "Do whatever he tells you" (*John* 2:5). In icons that present the Mother of Jesus, there is no book in her hands. Her hands hold the Son of God, the incarnate Word. Mary with a book in her hands would be more a master than the Mother. Jesus, standing, seated, or on his knees, embracing Mary, continues to say: "Blessed are those who hear and keep the Word of God and put it into practice" to all who wish to render praise to the motherhood of Mary (see *Luke* 11:27-28).

The icon in the tradition

The ministry of the preaching of the Word was first given to the Apostles, and this ministry of the Word became the Gospel, inspired by the Spirit. The original ministry of preaching is continued in the ministry of all who preach the Gospel, and the Spirit remains present in the preaching of the Church. It can also be claimed that the ministry of illumination is also achieved through the work of the Spirit, the result of openness to the Spirit.

The iconographer must be a believing Christian, just as the preacher must be a Christian. As the icon is not primarily art, so also the iconographer is not first and foremost an artist. Iconography is an action, a work both internal and external of a person totally open to the Spirit who asks for the grace to be able to love in a way that responds unconditionally to the Word. The Word that is produced through this form of "writing" becomes flesh in the life of the iconographer. The iconographer seeks Christian perfection through conversion, loyalty, docility, purification, penance, discipline, struggle, a participation in the ecclesiastical and liturgical life of the Church. The image of the Word, represented in an icon, before it is written on a tablet of wood, is written in the heart of the iconographer by means of the action of the Spirit. It is the face of the Lord written inside the iconographer's being that becomes imprinted on a piece of wood, on a cloth or on a wall, for the use and building up of the Christian community.

If the faces of the icons all seem to be the same, repetitive, this is because they all recall the unique and never-to-be-repeated link with the person of the Lord. No one can preach or write a new Gospel after the end of the apostolic era, but we must be always and uniquely challenged by these Sacred Scriptures. In a similar fashion, iconography is fixed according to established and received canons, in order to remain faithful to the one Gospel of Christ. It is the same Gospel that works, through the Spirit, in the believer and in the Church. Newness is not found in a new gospel, but in the ever-new reception of the same Gospel, as if it were written yesterday, for me, for the Church that lives today, and for the world of today.

The Christian and spiritual life is not the creation of a new gospel, but the readiness to become new as a result of obedience to the one true Gospel. It is not up to the Christian to create. The spirit of the

Gospel generates a new people of God: the Church. The world does not need new gospels, but a new humanity that allows itself to be shaped, transformed, and re-written by the living Word. The person searching for a new gospel is like one who searches for the signs of the coming of the reigning presence of God as King … but flees from daily commitment to the tasks of holiness that renew a person interiorly. Whoever becomes bored when looking at the canon of icons because they are repetitive, superficial, out of date, impersonal, is the same as the person who becomes bored on reading the same biblical pages written and preserved for us in the Christian Canon of Sacred Scripture. Just as the Bible was not written so that a literary figure might give vent to his or her personal inspiration, so also the image of the Lord found in the icon is not shaped by the skills of the artist, but by means of humble acceptance.

Many simple people across the history of the Church have spoken, written and painted, despite the fact that they were considered ignorant. The medieval paintings that adorned the walls of the great cathedrals or of simple Churches were called the "Bible of the poor," looked down upon by superior classes that disregarded those unable to read. Nevertheless, what blessedness is found among those who, even though they cannot read, know how to see and to believe. Indeed, iconography is the Bible of the poor and the Bible belongs to the poor. To them has been given the secrets of the Kingdom of heaven, because the Kingdom belongs to them (see *Matt* 5:3).

The task of those painted walls was not to teach the ignorant. The icons were a participation in the mysteries of the Kingdom that have been revealed to the poor. They become the colour, the joy, and the communion one finds in the Church. Perhaps today these same walls cry out to us in vain because of our "poverty," our distancing ourselves from that colour, joy and communion. In our own time, we run the risk of losing the power of communication that can be found in and through images.

The theological basis for iconography, first articulated in great Councils of the Church before it was divided, and since then preserved in both the East and the West, with different nuances, is the incarnation of the Son of God: a unique mystery of obedience which comes to pass in the fullness of time and had its beginnings with the origins of the universe. Over time it has shown its power

to give itself to the possibilities of the communication by means of human language, human writing, and human representation. Every page of the Bible and every icon is an eloquent and visible sign of this "wonderful divine condescension" that accepts the limitations of "dwelling among us" (see *John* 1:14).

Before and behind the mystery of the incarnation lies the mystery of the living God. For Christians this living God is a Trinity whose existence depends upon infinite love. God dwells in an eternal and loving "being in communion." From that source, the incarnation has its origins in the Trinitarian "being obedient" – one for the other, one in the other, one with the other. The obedience of the Son that burst forth in the incarnation renders historical, in the fullness of time, the "being obedient" that is at the heart of the life of the Trinity, and thus something that transcends all time.

The biblical Word of God and the iconic representation of that Word speak within time and space. They work at the edge between that which transcends all time, and the time and space made sacred by the incarnation. As Jesus' preaching was received and preserved in the Church by means of the preaching and the witness of the Apostles (the Gospel), so also the representation of his human form (the icon) has been entrusted to the tradition of the living Church. The mutuality of the preaching of the Word, found in the Bible, and the representation of the Word, found in the icon, form a rich and indivisible patrimony within the Church.

This normative and theological basis in the event of the incarnation not only undergirds the Christian practice of iconography. It also makes sense of the Christian presence in the world. Gazing at the icon, we confess the God who became flesh, and also the God who lived a fleshly life. The incarnation of God in and through Jesus Christ becomes the way we, in our turn, render the divine incarnate. The theological truth about Jesus as the incarnate Word lays the basis, and opens up the future to what we are called to become: in our own turn incarnations of the Word. The dogma of the incarnation becomes a theology, a spirituality ... of making the divine visible in the very flesh of our day-to-day lives.

Within a spirituality based on the incarnation, the icon does not distance the human being from the messiness of the human situation so that he or she can become closer to God. On the contrary, it enables

us to live our lives in one or other of the infinite ways possible in our world, a world loved in a remarkable fashion by God: he loved it so much that he sent his only Son (see *John* 3:16).

The icon confesses faith in the God made man, the firstborn of the new creation, given by God to humankind, to continue his "beautiful and excellent" creative work. But all too often, the response to God's command has been disobedience, pride, selfishness, and jealousy. The human situation knows a great deal of pain and hardship. Whoever writes or paints icons attempts to speak to this broken world. He or she works for the recapitulation of the universe, bringing into the world the redemptive work of God. It is not just one task among many others, but a vocation to a particular ecclesial ministry, following the example of the Mother of God who gave flesh to the Word, human visibility to divine invisibility. The iconographer also accepts the mission handed down by the Apostles. As their ministry continued the saving presence of Jesus Christ in the Church, so also does that of the iconographer.

The icon in the Liturgy

The presence of the icon might serve us in the renewal of the Church's Liturgy, following the directions of the Second Vatican Council. Iconography is at the service of Christian faith, and finds its privileged context within the Liturgy. Iconography is sustained by the Liturgy because the Liturgy is the incarnation of the invisible mystery of the Church, in its gatherings, in its external actions and, at the right moment, in the sending forth of the believer into the world as leaven. Within the liturgical context God speaks "as he has spoken to our fathers" (see *Heb* 1:1). The Liturgy of the Word, formed by the moment of reading, listening, the explanation that comes from the person presiding, the proclamation of faith and the prayers of intercession for the Church, the world, and the praying community, has its own internal logic. From the listening, guided by the explanation, the faith of the Church is born or strengthened.

In the same way, we must be vividly aware of the intimate link that exists between the Liturgy of the Word and the Liturgy of the Sacrament. In the Liturgy of the Sacrament the Word bursts forth in

all its visibility, in its deep sacramentality. The Sacrament is feeding at the Word that has become nourishment, through listening to the Liturgy of the Word, down to the "amen" proclaimed before the bread and wine. If one does not first listen to the Word, with what is he or she nourished? Communion with the body and blood of the Lord cannot be separated from his Word, as if the sacramental action had nothing to do with the proclamation of the Word within the liturgical celebration.

The Liturgy offers us many reminders of the dynamic unity of Word and Sacrament: the Preface which acts as a bridge between the two liturgical moments, the reminder of our needs before beginning the Lord's Prayer, the antiphon that is to be said during communion, and not "after" communion. It is good to remember that this antiphon can be prayed over and over. As we receive the body and blood of the Lord, reading or singing his praise reminds us that we have reached the moment where the two essential elements of the Liturgy become one: the Word and the Sacrament.

The icon can be a witness to what is seen and heard. The icon bears the stamp of the proclaimed Word, the professed Word and the prayed Word, but especially the Word become Sacrament by means of communion. The sense of mystery linking the Word that is heard and the Word that becomes Sacrament must be maintained and a correct use of the icon within the Liturgy can guide us to better understanding the oneness that exists between Word and Sacrament.

The icon also sustains the Liturgy by recalling the presence of Jesus Christ who gathers, who speaks and who offers himself. We can gather around an icon, or make a pilgrimage to a place where a "miraculous" icon is found. Once we are before the icon, however, the reason for the gathering becomes secondary. We experience a joyous return to the Word made flesh, a comfort and a vision that encourage us to turn to the fullness of the liturgical encounter in the Liturgies of the Sacraments of Reconciliation, Eucharist, Anointing of the Sick and Marriage.

Icons are never an end in themselves, but humble angels of the one who sent them. The icon is not an alternative or a challenger to the liturgical life of the Church. It should not be placed on a throne in isolation. The stand for the icon must not be separated from the

throne of the Word, and vice-versa. This is especially the case for the celebrations of Sunday, the Day of the Lord, as for the great Christian Solemnities and the Feasts of the Saints. The Word of God proclaimed on that day should be found side by side with the icon, anticipating the holiness to which the Church and every Christian has been called. We need more icons given their correct place: side by side with the Word of God. In this way we are guided in our "hearing" of the voice of God, and our "sight" of his incarnate Son.

Francis J. Moloney, SDB

LIFE OF JESUS
IN ICONS
FROM THE "BIBLE OF TBILISI"

1

The Annunciation
Luke 1:26-33

26 In the sixth month the angel Gabriel was sent by God to a town in Galilee called Nazareth, 27 to a virgin engaged to a man whose name was Joseph, of the house of David. The virgin's name was Mary. 28 And he came to her and said, "Greetings, favoured one! The Lord is with you." 29 But she was much perplexed by his words and pondered what sort of greeting this might be. 30 The angel said to her, "Do not be afraid, Mary, for you have found favour with God. 31 And now, you will conceive in your womb and bear a son, and you will name him Jesus. 32 He will be great, and will be called the Son of the Most High, and the Lord God will give to him the throne of his ancestor David. 33 He will reign over the house of Jacob forever, and of his kingdom there will be no end."

The Gospel of Luke reports two annunciations: one to Zechariah and one to Mary, the Mother of Jesus. If what God can do for Elizabeth is wonderful, how much more wonderful is the overshadowing of Mary with the Spirit and the annunciation that the child she will bear will not only be the expected Messiah who will reign over the house of Jacob forever, but "he will be called Son of God"? How Mary struggles with this! At the greeting of the angel Gabriel she was perplexed and wondered what such a greeting might mean. When she is told that she should not fear, but know that God has loved her so much that she will bear the Messiah, she can only raise a practical question: "How can this be, since I am a virgin?" Only when Gabriel makes it clear that her future as the Mother of the Son of God is the result of the direct action of the Spirit of God, taking possession of all that she is and all that she will be in the future does she finally allow an unconditional faith and trust in God possess her: "Let it be with me according to your Word." In this unforgettable biblical moment, Mary becomes the first of all believers, and shows us the way through doubt and reason to true faith.

The icon shows her rising from her seat, ready to listen. The palm of her right hand, turned upwards, suggests her initial reserve, but her

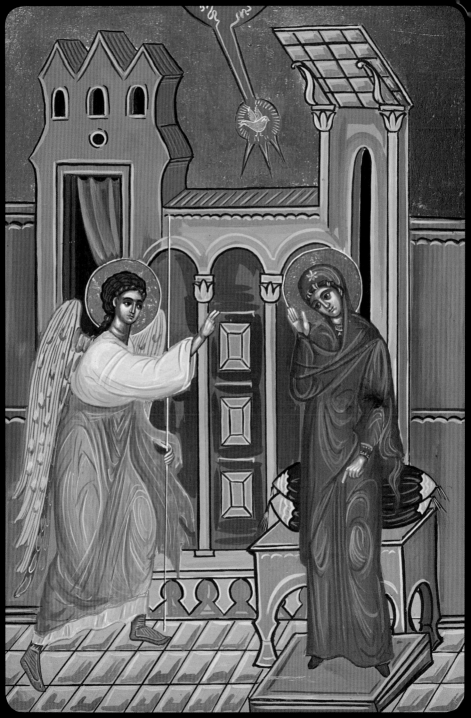

obediently bowed head prepares itself for her final act of faith. Here, and in the icons representing Jesus' birth stories, she is dressed in a deep red robe. This is the colour of the curtain that covered the Holy of Holies. She now holds the presence of the living God within her. She leads the way for us towards an acceptance of the greatest of all truths: "Nothing will be impossible with God" (v. 37).

Francis J. Moloney, SDB

Indeed and indeed she did the Father's will and it is a greater thing for her that she was Christ's disciple than she was his mother. It is a happier thing to be his disciple than to be his mother. Blessed then is Mary who bore her Lord in her body before she gave him birth.

See if it is not as I say. The Lord was journeying on and the crowds were following him. He did a work of divine power and this woman in the crowd cried out: "Blessed is the womb that bore you and the breasts that you sucked" (*Luke* 11:27). But they must not think that blessedness lay in bodily relationship, so what did the Lord answer? "Blessed rather are those that hear the word of God and keep it" (v. 28). Therefore Mary is blessed because she "heard the word of God and kept it." Her mind was filled more fully with truth than her womb by his flesh. Christ is the truth, Christ is made flesh: Christ the truth is in Mary's mind, Christ made flesh is in her womb. Greater is that which is in her mind than that which she carried in her womb.

Saint Augustine, *Sermon* XXV, 7-8

How quickly Mary believed concerning her unheard of and impossible situation in life! How distant are the Holy Spirit and a human body? Has a virgin with child ever been heard of? Such a situation is against the Law, physically impossible, and an apparent offence against modesty.

Saint Ambrose,
Exposition of the Holy Gospel according to Saint Luke, II, 17

Mary, when she says, "How shall this be, seeing that I know not a man?" (*Luke* 1:34), does not seem to doubt the possibility of her giving birth. She enquires about the way it would happen. Clearly, she who asked how it could be done believed that it would come to pass. For this reason she is rightly told: "Blessed is she who has believed" (*Luke* 1:45). And she who is more exalted in the eyes of God than the priest Zechariah is truly blessed. What the priest had denied, the Virgin corrected by her acceptance. It is not strange that the Lord, the saviour of the world, began his work with Mary. She, through whom salvation was prepared for all, is thus the first to draw the fruits of salvation from her Child.

Saint Ambrose,
Exposition of the Holy Gospel according to Saint Luke, II, 17

2

The Visitation
Luke 1:39-45

³⁹ In those days Mary set out and went with haste to a Judean town in the hill country, ⁴⁰ where she entered the house of Zechariah and greeted Elizabeth. ⁴¹ When Elizabeth heard Mary's greeting, the child leaped in her womb. And Elizabeth was filled with the Holy Spirit ⁴² and exclaimed with a loud cry, "Blessed are you among women, and blessed is the fruit of your womb. ⁴³ And why has this happened to me, that the mother of my Lord comes to me? ⁴⁴ For as soon as I heard the sound of your greeting, the child in my womb leaped for joy. ⁴⁵ And blessed is she who believed that there would be a fulfillment of what was spoken to her by the Lord."

Two mothers meet. There can be no doubt about the greatness of the action of God upon the flesh of each of these women, but it is the very flesh of Elizabeth that makes her aware of the greatness of her young kinswoman, and of the child she is bearing. Elizabeth is to be the mother of the precursor of the Messiah and Saviour. Mary is to be the mother of the Messiah and Son of God. The deep red robe in the icon continues to tell that truth. As Elizabeth's child quickens in her womb, she is overcome with the presence of the Holy Spirit. She takes Mary in her arms and salutes her as "the mother of my Lord." But Elizabeth is also aware of the source of Mary's greatness: "Blessed is she who believed that there would be a fulfilment of what was spoken to her by the Lord." Mary will echo the same profound truth when she proclaims, in answer to the greeting of Elizabeth, her Magnificat: "He who is mighty has done great things for me, and holy is his name".

For the icon, age does not seem important. Both mothers have been blessed by God: a golden halo surrounds both heads. They are related, but there is a deeper harmony between them: in their gazes, their extended hands, their touching, the position of their feet and their flowing robes. At the top of the icon a veil – repeating the colour of Mary's robe,

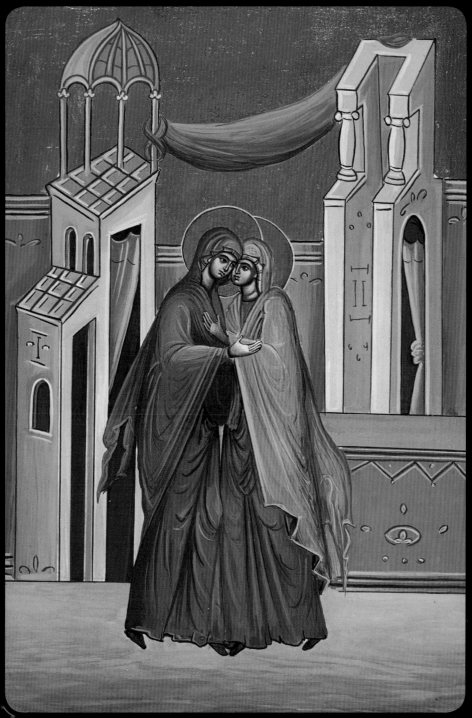

connects the two houses, expressing and protecting the mystery that is now being borne, wrapped in the form of the two mothers.

<div align="right">Francis J. Moloney, SDB</div>

A kinswoman came to her close relative. Not only did the younger one come to the elder, but Mary was the first to greet Elizabeth (see *Luke* 1:40). It is fitting that the chaste virgin, the more humble, act in this way. May she know how to defer to her seniors; may she who professes chastity also be the mistress of humility.

It is a cause of religious wonder, but also a part of the Christian belief. The superior comes to the inferior, so that the inferior is cherished. Mary comes to Elizabeth, Christ to John. Later, in order to render the baptism of John holy, the Lord came to John for baptism (see *Matt* 3:13). In the moment of Mary's arrival the blessings of the divine presence are recognised and confessed. As soon as Elizabeth heard the salutation of Mary the infant leapt in her womb; she was filled with the Holy Spirit.

<div align="right">Saint Ambrose,
Exposition of the Holy Gospel
according to Saint Luke, II, 22</div>

Notice that Mary did not doubt, but believed and thus obtained the fruit of faith. "Blessed", says Elizabeth, "is she who has believed" (*Luke* 1:45). But you who have heard and believed are also blessed. A soul which has believed has conceived and bears the Word of God and declares God's works. Let the soul of Mary be in each of us, so that it magnifies the Lord; let the spirit of Mary be in each of us, so that we rejoice in God (cf. *Luke* 1:46-47). As Mary is the one mother of Christ according to the flesh, so also Christ is the fruit of all of us according to the faith. Every soul receives the word of God, as long as it guards its purity with inviolate modesty.

Each and every soul who bears Christ in this way magnifies the Lord, as the soul of Mary magnified the Lord, and her spirit rejoiced in God her saviour.

Saint Ambrose, *Exposition of the Holy Gospel according to Saint Luke*, II, 26-27

"And Mary stayed with her for about three months, and then she returned to her own house" (*Luke* 1:56). Mary is presented in the Gospel story as having performed her duty. She also abides for three months: the mystic number three, representing perfection. She remained there for this period of time, not only because of her relative Elizabeth, but also to accompany the growth of a great prophet. So much progression in grace occurred at the first meeting between the two mothers. The infant leapt in the womb at Mary's salutation and Elizabeth was filled with the Holy Spirit on that occasion. How much more can we imagine the long and close presence of Mary would have added?

Saint Ambrose, *Exposition of the Holy Gospel according to Saint Luke*, II, 29

3

The Birth of John the Baptist
Luke 1:57-66

> [57] Now the time came for Elizabeth to give birth, and she bore a son. [58] Her neighbours and relatives heard that the Lord had shown his great mercy to her, and they rejoiced with her. [59] On the eighth day they came to circumcise the child, and they were going to name him Zechariah after his father. [60] But his mother said, "No; he is to be called John." [61] They said to her, "None of your relatives has this name." [62] Then they began motioning to his father to find out what name he wanted to give him. [63] He asked for a writing tablet and wrote, "His name is John." And all of them were amazed. [64] Immediately his mouth was opened and his tongue freed, and he began to speak, praising God. [65] Fear came over all their neighbours, and all these things were talked about throughout the entire hill country of Judea. [66] All who heard them pondered them and said, "What then will this child become?" For, indeed, the hand of the Lord was with him.

Two points of view are communicated as this moment unfolds. On the one hand there are the neighbours and relatives who rejoice and come to join the celebration. They expect Zechariah and Elizabeth to do what everyone else would do: give the baby a name that belongs to the family. They come bringing their gifts and food to share at the celebration. The other point of view is held by the two saints (the only ones in the icon with golden haloes): Elizabeth and Zechariah. They have been instructed by the angel of the Lord to call the baby "John". In their unswerving righteousness and openness to what God has asked from them, Elizabeth insists, and Zechariah joins her as he writes "His name is John" on the tablet. Two contrasting conclusions emerge from these two points of view. The friends and neighbours go away amazed, aware that something rare has taken place, but only able to ask questions about what might happen with this child. But Zechariah, freed from his dumbness, is able to proclaim the great blessedness of God who has done such things for him in the Benedictus: "Blessed be the Lord, the God of Israel, for he has looked favourably on his people and redeemed them" (*Luke* 1:68-79).

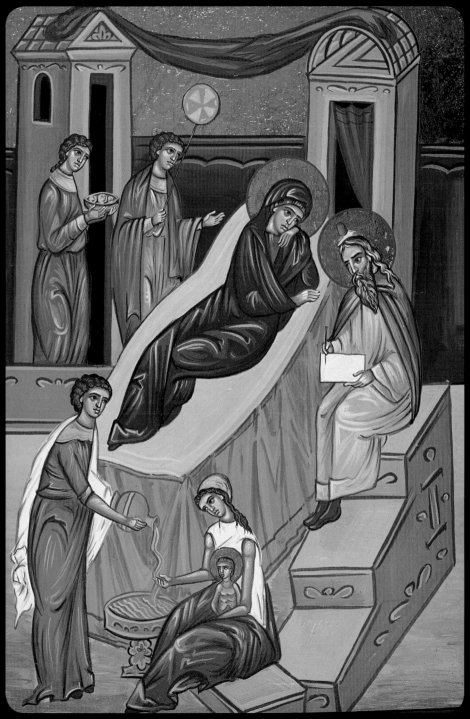

The icon catches this in the three scenes: the arrival of the neighbours and the relatives, a detached scene of the baby and his post-circumcision bath, and at the centre: Elizabeth observing Zechariah, still speechless in disbelief, writing the baby's name on the tablet. The union of the couple at the centre of the icon shows their mutual obedience to the command of the angel: "You will name him John" (*Luke* 1:13). The neighbours and relatives, the attendants and the baby himself are but the framework for what is happening at the centre of the icon.

Francis J. Moloney, SDB

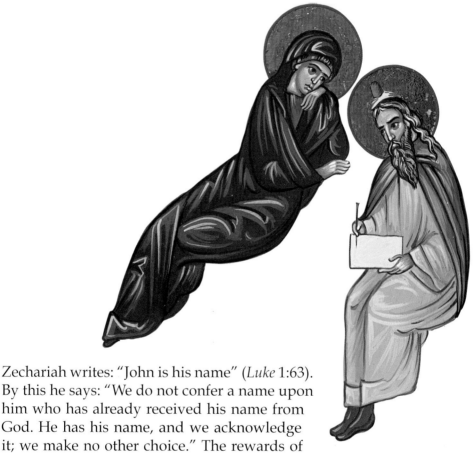

Zechariah writes: "John is his name" (*Luke* 1:63). By this he says: "We do not confer a name upon him who has already received his name from God. He has his name, and we acknowledge it; we make no other choice." The rewards of many saints include the fact that they receive a name from God. Thus, Jacob is called "Israel" because he saw God (see *Genesis* 32:28). Thus our Lord was called "Jesus" before he was born, he on whom not an angel, but the Father conferred his name.

Saint Ambrose, *Exposition of the Holy Gospel according to Saint Luke*, II, 31

32

It is right to know that none of his family was called by this name. This name does not come from family tradition, but from the prophecy uttered by the Angel. Zechariah was questioned by a sign, but as his unbelief had taken his speech and hearing from him, he spoke with his hand and letters rather than with his voice. "He wrote, saying 'John is his name'" (*Luke* 1:63). John's name is not imposed, but given by God. From that point on Zechariah's tongue is deservedly loosed, because faith releases what disbelief has bound. So let us also believe, that we may speak (see *Psalm* 115:11; *2 Cor* 4:13), that our tongue which is bound by the fetters of unbelief may be released by the voice of reason. Let us write mysteries in the Spirit if we wish to speak (see *1 Cor* 14:2). Let us write the prophecy of Christ, not in tables of stone, but in the fleshly tables of the heart (*2 Cor* 3:3). Indeed, the person who says, "John," prophesies Christ. Let us say "John"; let us also say "Christ", so that our mouths may also be opened, unlike that important but doubting priest.

Saint Ambrose, *Exposition of the Holy Gospel according to Saint Luke*, II, 32

See how God, good and willing to forgive sins (see *Psalm* 72:1), not only restored what was taken away, but also conferred the unexpected. He who before was dumb, prophesies. This is the wonder of God's grace: those who denied him confess him. Therefore let no one be lacking in trust; let no one, aware of the sins of the past, despair of divine rewards. God knows how to change his mind, as long as we recognise our sinfulness.

Saint Ambrose,
Exposition of the Holy Gospel according to Saint Luke, II, 33

33

The Birth of the Saviour
Luke 2:1-11, 15-19

[1] In those days a decree went out from Emperor Augustus that all the world should be registered. [2] This was the first registration and was taken while Quirinius was governor of Syria. [3] All went to their own towns to be registered. [4] Joseph also went from the town of Nazareth in Galilee to Judea, to the city of David called Bethlehem, because he was descended from the house and family of David. [5] He went to be registered with Mary, to whom he was engaged and who was expecting a child. [6] While they were there, the time came for her to deliver her child. [7] And she gave birth to her firstborn son and wrapped him in bands of cloth, and laid him in a manger, because there was no place for them in the inn. [8] In that region there were shepherds living in the fields, keeping watch over their flock by night. [9] Then an angel of the Lord stood before them, and the glory of the Lord shone around them, and they were terrified. [10] But the angel said to them, "Do not be afraid; for see – I am bringing you good news of great joy for all the people: [11] to you is born this day in the city of David a Saviour, who is the Messiah, the Lord. […] [15] When the angels had left them and gone into heaven, the shepherds said to one another, "Let us go now to Bethlehem and see this thing that has taken place, which the Lord has made known to us." [16] So they went with haste and found Mary and Joseph, and the child lying in the manger. [17] When they saw this, they made known what had been told them about this child; [18] and all who heard it were amazed at what the shepherds told them. [19] But Mary treasured all these words and pondered them in her heart.

Joseph and Mary set out from Nazareth to Bethlehem, the town of David. Jesus is born while his Mother and Joseph are on a journey, a relentless journey that will not end until he returns to his Father by means of his Ascension. At his birth, he is wrapped in swaddling cloths and placed in a manger so that Israel might find its nourishment. This child, a king born on a journey who is to provide hope and nourishment for all, is revealed to people who come from the margins of society: the shepherds who are told of a Saviour, a Messiah, the Lord. In Bethlehem they find the child, Mary and Joseph, and then depart to tell everyone what has happened. Amazement surrounds the birth of this child … but not faith. It is not until the Gospel passage comes to its conclusion that we hear

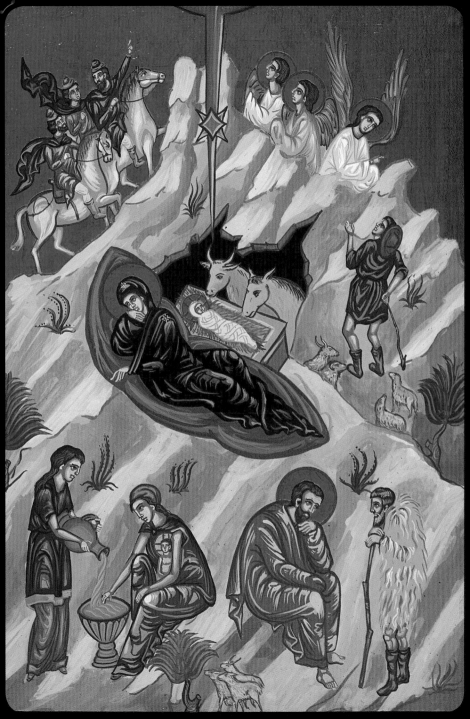

of the response of the one who has believed in the Word of God at the Annunciation. Mary treasured all that had happened and had been said in the birth of her Son. She does not understand, but she received these mysteries into the depth of her being and ponders them, accepting the Word, and acting upon it, cost her what it may.

The icon tells more than Luke's story. Angels and shepherds, the infant, the Mother and Joseph are there. The child has been born. Mary no longer wears the deep red robe, but that color now surrounds her, as it surrounds all who gaze upon the icon. But we also see the oxen at the crib, a traditional addition to the Christmas story, and events that are recorded in the Gospel of Matthew: the star over the crib, the wise men coming from the East. Everything is arranged around the Mother. Joseph chats with one of the shepherds, a servant woman prepares to bathe the swaddled child, the angels and the wise men have their eyes cast elsewhere. Our eyes fasten upon the vibrantly coloured figure at the centre of the icon: Mary, lying on her side with her hand outstretched in invitation, asking us to treasure all these things and ponder them in our hearts.

<div align="right">Francis J. Moloney, SDB</div>

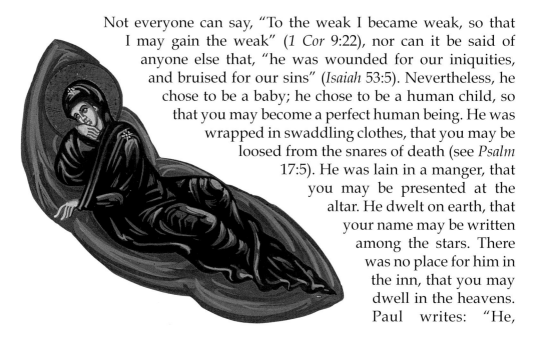

Not everyone can say, "To the weak I became weak, so that I may gain the weak" (*1 Cor* 9:22), nor can it be said of anyone else that, "he was wounded for our iniquities, and bruised for our sins" (*Isaiah* 53:5). Nevertheless, he chose to be a baby; he chose to be a human child, so that you may become a perfect human being. He was wrapped in swaddling clothes, that you may be loosed from the snares of death (see *Psalm* 17:5). He was lain in a manger, that you may be presented at the altar. He dwelt on earth, that your name may be written among the stars. There was no place for him in the inn, that you may dwell in the heavens. Paul writes: "He,

being rich, became poor for your sakes, that through his poverty you might be rich" (*2 Cor* 8:9). His poverty is my inheritance, and the Lord's weakness is my strength. He chose to go without, that he could give great abundance to everyone. The weeping of that child cleanses me, those tears wash away my sins. Therefore, Lord Jesus, my redemption flows from all that you suffered, even more than my very creation owes to your power in creating me. It would be useless to have been born, if not to reap the riches of redemption.

Saint Ambrose, *Exposition of the Holy Gospel according to Saint Luke*, II, 41

"But Mary kept all these words, pondering them in her heart" (*Luke* 2:19). Let us learn the great truths from the holy Virgin, pure in word just as she was in body. She meditated in her heart the great truths of the faith. If Mary learns from the shepherds, why do you resist the teaching of the bishops? If Mary is silent in the period before the teaching of the Apostles, why do you, now that they have delivered their teaching, desire to reject that teaching, rather than to learn from it? We must come to acknowledge that there is no fault in the diversity that marks the sexuality of man and woman. Sexuality is sacred. Learn that the source of all errors is to be found in the individual. Even though Mary was not given any command to do so, she showed us how to live by her example.

Saint Ambrose,
Exposition of the Holy Gospel according to Saint Luke, II, 54

5

The Adoration of the Magi
Matthew 2:1-5, 7-11

> [1] In the time of King Herod, after Jesus was born in Bethlehem of Judea, wise men from the East came to Jerusalem, [2] asking, "Where is the child who has been born king of the Jews? For we observed his star at its rising, and have come to pay him homage." [3] When King Herod heard this, he was frightened, and all Jerusalem with him; [4] and calling together all the chief priests and scribes of the people, he inquired of them where the Messiah was to be born. [5] They told him, "In Bethlehem of Judea; for so it has been written by the prophet. [...] [7] Then Herod secretly called for the wise men and learned from them the exact time when the star had appeared. [8] Then he sent them to Bethlehem, saying, "Go and search diligently for the child; and when you have found him, bring me word so that I may also go and pay him homage." [9] When they had heard the king, they set out; and there, ahead of them, went the star that they had seen at its rising, until it stopped over the place where the child was. [10] When they saw that the star had stopped, they were overwhelmed with joy. [11] On entering the house, they saw the child with Mary his mother; and they knelt down and paid him homage. Then, opening their treasure chests, they offered him gifts of gold, frankincense, and myrrh.

Wise men from the East, who read the signs in the heavens, follow the star in search of the child who has been born King of the Jews. They come to the right place. Jerusalem is the holy city, and the Prophet uttering the Word of God points them to the city of David. But there is already a King in Jerusalem: Herod! Instead of welcoming the gift of the true King of Israel, a false King and an unbelieving people are frightened. Herod lurks behind the scenes as the wise men continue their journey and come to find the true King. They lower themselves to the ground in homage, and bring gifts that, at one and the same time, honour the newborn king, and point to his destiny: gold, incense and myrrh. He will be slain and anointed for burial. This danger already threatens as Herod waits his opportunity to dispose of the child.

The icon continues the story told by the previous icon on the birth of Jesus, but it is greatly simplified. The wise men come to Mary with their

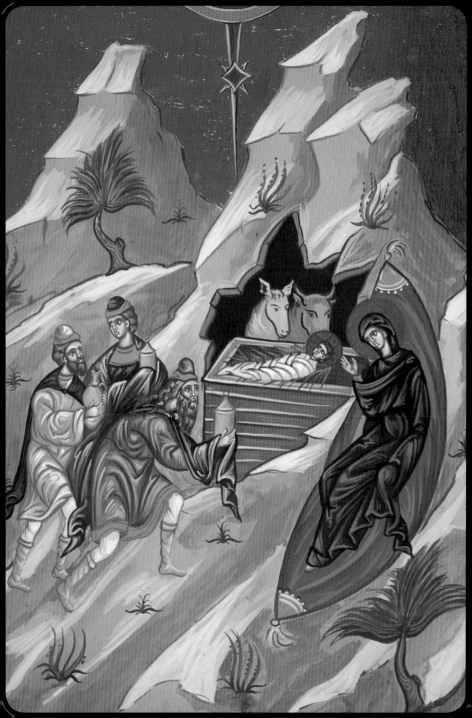

gifts, and they have not yet bowed to the ground. They are naturally attracted to Mary, the most obvious person in the forefront of the scene … but that is not where homage is due. In the previous icon Mary invited all who look at the icon to join her. Surrounded by the deep red that marks her as the one who has given birth to the Son of God, she points away from herself so that due homage may be made to the child. However, as in the previous icon, the child is resting upon a palm – the symbol of martyrdom. The swaddled child is found at the centre of the icon and that is where the wise men must place their hope.

Francis J. Moloney, SDB

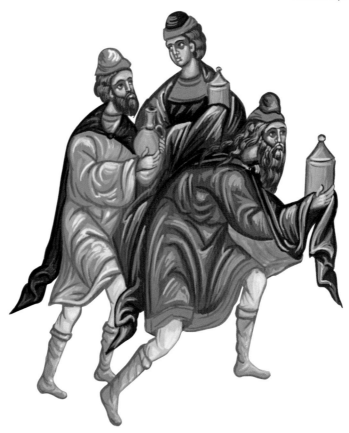

He had chosen the nation of Israel and – from that nation – one family in particular as the one from which to take up the nature of all humanity. Still, he did not want the beginnings of his appearance to remain hidden within the dwelling of his mother. Instead he wanted to be acknowledged right away by all, since he had seen fit to be born for all.

Consequently, a star with new brilliance appeared to three wise men in the East. Since it was brighter and more beautiful than others, it easily attracted to itself the eyes and hearts of those looking on. Immediately they realised that what seemed so unusual could not be without meaning. He who furnished the sign also gave understanding to those who saw it. What he granted to be understood, he also granted to be sought. At last, he who was sought offered himself to be found.

Saint Leo the Great, *Sermon* XXXI, 1

Three men follow the lead of this heavenly light. While trailing the signal of its gleam ahead of them with their attention focused on it, they are led by the splendour of grace to knowledge of truth.

Saint Leo the Great, *Sermon* XXXI, 2

The wise men fulfil their desire, coming to the child, the Lord Jesus Christ, as the same star leads them. They adore the Word in flesh, Wisdom in infancy, strength in weakness, and the Lord of Majesty in the reality of a man.

To reveal the mystery of their faith and understanding, they confirm with gifts what they believe in their hearts. They offer incense to God, myrrh to the man, and gold to the king. Knowingly do they venerate the divine and human nature in their oneness. What was a proper characteristic of one or the other substance did not remain separated from the other in power.

Saint Leo the Great, *Sermon* XXXI, 2

6

The Presentation of Jesus in the Temple
Luke 2:22, 25-32

> [22] When the time came for their purification according to the law of Moses, they brought him up to Jerusalem to present him to the Lord. […] [25] Now there was a man in Jerusalem whose name was Simeon; this man was righteous and devout, looking forward to the consolation of Israel, and the Holy Spirit rested on him. [26] It had been revealed to him by the Holy Spirit that he would not see death before he had seen the Lord's Messiah. [27] Guided by the Spirit, Simeon came into the temple; and when the parents brought in the child Jesus, to do for him what was customary under the law, [28] Simeon took him in his arms and praised God, saying, [29] "Master, now you are dismissing your servant in peace, according to your word; [30] for my eyes have seen your salvation, [31] which you have prepared in the presence of all peoples, [32] a light for revelation to the Gentiles and for glory to your people Israel."

In observance of the Law of Israel, Mary and Joseph come to the Temple for the rite of purification after the birth of their child. But all that God had made known through Moses and his Law is about to be brought to perfection. Simeon and Anna wait. They are elderly and righteous people who happened to be in the Temple that day. They represent the hope of Israel, the waiting of Israel. Inspired by the Holy Spirit, Simeon announces that the coming of this child marks the turning point of the ages. No longer does God speak to a chosen people through a single Law. Now he has come as the light for all nations. The eyes of Simeon are the eyes of the whole of the history of God's people. Their waiting is over. His eyes have seen the salvation that God has prepared for all peoples. Jesus is to be a revelation of the glory of God to Israel and to all nations.

The icon catches this mystery through several significant details. The roles of the Father and the Mother are reversed. Mary presents the child to Simeon, while Joseph brings the offering of the two doves, a quiet hint of the role of Mary as the Virgin Mother of the Lord. Arms are upraised as this offering is made by the Mother of Jesus to the representative of a waiting Israel who accepts the child whose tiny hand reaches out in a

42

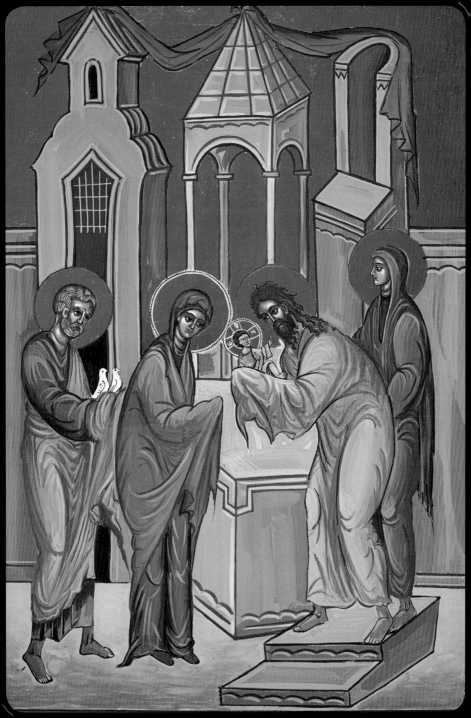

gesture of union. Across the top of the icon a red banner links both sides of the presentation: those giving and those receiving. But that red is no longer the red of the veil that covered the Holy of Holies. The child is now separated from his mother. In the presentation of Jesus, Israel and all the nations awaiting the revelation of the glory of God are joined to the one offering that revelation: Jesus.

<div align="right">Francis J. Moloney, SDB</div>

The birth of the Lord is attested not only by the angels and the prophets, the shepherds and his parents, but also by the elders and the just. All ages, both sexes, and the miracles of events guarantee faith in Jesus' birth: a virgin conceives, a barren woman gives birth, a dumb man speaks, Elizabeth prophesies, Magi adore, a babe in the womb rejoices. But an elderly widow also praises God (see *Luke* 2:38), and a just man waits. How right it is to call him a just man. He did not seek favours for himself, but for the people. While he longed to be released from the bonds of his own bodily weakness, he waited to see the Promised One (see *Luke* 2:26). He knew that "blessed are the eyes which see" (*Luke* 10:23).

<div align="right">Saint Ambrose, Exposition of the Holy Gospel according to Saint Luke, II, 58</div>

Simeon calls out: "Now, Lord, you can let your servant go in peace" (*Luke* 2:29). This just man, aware that to live this earthly existence also means dwelling in a bodily prison, wishes to be set free. Then he can be with Christ; for "to depart and to be with Christ is far better" (*Phil* 1:23). But let him who wishes to depart, first come to the Temple; let him come to Jerusalem. Let him await the Lord's Christ, and receive into his hands the Word of God. Let him embrace him with the arms of faith (see *Luke* 2:27-28). Then he can depart. So that, having seen the true Life, he will never again see death.

<div align="right">Saint Ambrose, Exposition of the Holy Gospel according to Saint Luke, II, 59</div>

Be aware that an abundance of grace was imparted to all through the birth of the Lord. The gift of prophecy is never denied to those who believe, but only to those who do not believe. Simeon prophesies that the Lord Jesus has come for the fall and for the rising of many (*Luke* 2:34), to discern the worthiness of the righteous and of the wicked. As a true and just judge he will decide on punishment or rewards, according to the worthiness of our deeds.

Saint Ambrose, *Exposition of the Holy Gospel according to Saint Luke*, II, 60

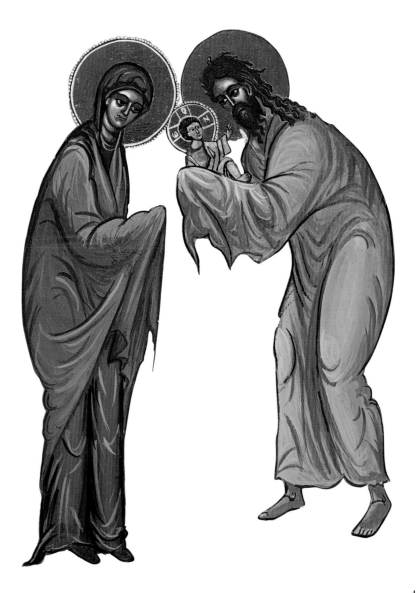

The Flight to Egypt
Matthew 2:13-15

> [13] Now after they had left, an angel of the Lord appeared to Joseph in a dream and said, "Get up, take the child and his mother, and flee to Egypt, and remain there until I tell you; for Herod is about to search for the child, to destroy him." [14] Then Joseph got up, took the child and his mother by night, and went to Egypt, [15] and remained there until the death of Herod. This was to fulfill what had been spoken by the Lord through the prophet, "Out of Egypt I have called my son."

The story of Jesus' infancy, as it is told in Matthew's Gospel, is permeated with threat and danger for the newborn child. In our reflection on the adoration of the Magi we already noticed the lurking presence of King Herod, terrified by the news that another "King of the Jews" had just been born. But God is the master of all these events, tragic as they appear to us. The Lord sends his messenger, an angel, to warn Joseph of Herod's plans to destroy Jesus. This is the second time Joseph has experienced the presence of God in his life in this spectacular fashion. Despite Mary's pregnancy, he was told by an angel to take her as his wife (*Matt* 1:20). Joseph is now aware that the child entrusted to his care is the result of the intervention of the Holy Spirit, and that his name will be Jesus, for he will save his people from their sins (vv. 20-21).

He has no hesitation. In wordless obedience, always a sign in the Bible of a complete conformity to the will of God, Joseph does what he is told. In the darkness of the night the family leaves Bethlehem and takes the road for Egypt. Then, to conclude this passage, Matthew tells us that the apparent tragedy of this flight from the merciless slaying that Herod has in mind for the children of Bethlehem is part of God's design. Jesus will eventually return to his homeland, Israel, from Egypt. This journey from Egypt to take possession of the land of Israel had taken place in the days of Moses and at the beginnings of the life of a people chosen by God. It was of them that the Prophet Hosea had written: "Out of Egypt I have called my son" (*Hosea* 11:1). But now the unique Son of God is located

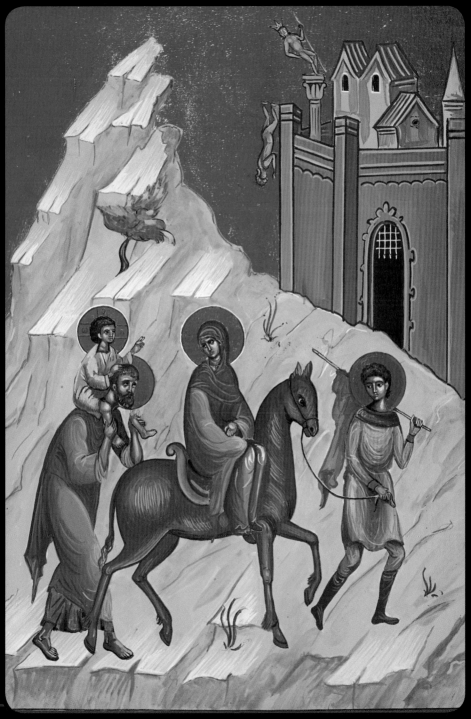

in Egypt as the result of human wickedness. But the plan of God for his Son and his People can thus be fulfilled, as Jesus will come back to his home "out of Egypt."

The icon takes us into the biblical account, and beyond it by means of tales that were told in other early Christian stories. The more muted red color of Mary's clothing and the banner that precedes her continues to highlight her importance, as the family serenely wends its way to Egypt, obedient to the command of the angel of the Lord. Joseph's role as a caring father is caught as he carries Mary's child on his shoulders, while Jesus and his Mother fix one another in a gaze. The child raises his hand, and the gods of the Egyptians tumble from their places of honor, while a son of Joseph by a former marriage (according to a tradition of the Eastern Church) leads the cortege on its way.

Francis J. Moloney, SDB

Why did God not protect the Magi and the young child, allowing them to remain in Palestine? Instead, they had to flee: the Magi to Persia and the child with his mother to Egypt. The angel quickly sends the wise men back to their homeland, commissioning them to proclaim Jesus Christ in the land of the Persians. This foils the cruel fury of King Herod, so that he may come to understand that he was attempting the impossible, and that his wrath was in vain and his efforts would have no effect.

But why is the young child sent into Egypt? The evangelist himself gives the principal reason: that the prophecy may be fulfilled, "Out of Egypt I have called my son" (*Hosea* 11:1). It was also done to announce to all peoples the beginnings of a great hope that they would have to keep alive into the future. As Babylon and Egypt, more then the rest of the world, had been caught up in the flames of ungodliness, God reveals that he intends to convert them. He will purify them and elevate their way of life. In this way, God gives the whole world hope of obtaining a parallel renewal of goodness. It was for this reason that God sent the Magi to Babylon, and the child and his mother Egypt.

On top of this, there is another precious detail in the flight to Egypt which we can use to motivate ourselves to greater virtue. We need to be aware, from the earliest days of our lives, that we should expect temptations and dangers. Keep in mind that from the very crib of his birth,

this was the experience of Jesus. As soon as he was born the fury of a tyrant was let loose against him, forcing him to flee into exile. And his pure and innocent mother had to escape into Egypt, a land of strangers.

This example should direct you to gladly accept misfortune, and teach you that normally this is the lot of those who dedicate themselves to matters spiritual. Trials and tribulations will be your inseparable companions. Notice also that this happened not only to Jesus and his Mother, but also to the Magi. They had to flee in secret like evildoers, and the Virgin, who would have always been dedicated to her home, had to undertake a long and exhausting journey. All this took place as the consequence of a remarkable spiritual birth.

<div align="right">Saint John Chrysostom, Homilies on the Gospel of Matthew, VIII, 2</div>

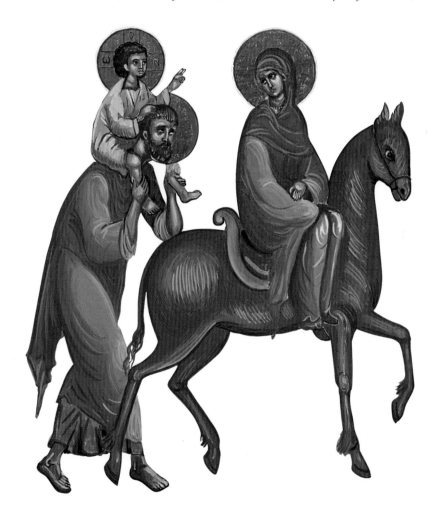

Jesus among the Teachers of the Law
Luke 2:41-51

> [41] Now every year his parents went to Jerusalem for the festival of the Passover. [42] And when he was twelve years old, they went up as usual for the festival. [43] When the festival was ended and they started to return, the boy Jesus stayed behind in Jerusalem, but his parents did not know it. [44] Assuming that he was in the group of travellers, they went a day's journey. Then they started to look for him among their relatives and friends. [45] When they did not find him, they returned to Jerusalem to search for him. [46] After three days they found him in the temple, sitting among the teachers, listening to them and asking them questions. [47] And all who heard him were amazed at his understanding and his answers. [48] When his parents saw him they were astonished; and his mother said to him, "Child, why have you treated us like this? Look, your father and I have been searching for you in great anxiety." [49] He said to them, "Why were you searching for me? Did you not know that I must be in my Father's house?" [50] But they did not understand what he said to them. [51] Then he went down with them and came to Nazareth, and was obedient to them. His mother treasured all these things in her heart.

After the two annunciations (to Zechariah and Mary), the visitation, and the two stories of birth and naming (John and Jesus), the Gospel of Luke closes Jesus' infancy narrative with two events that take place in the Temple: the presentation of Jesus to Simeon, and the finding of the child Jesus in the Temple. For Israel, the Temple is the dwelling place of God among his people. Jesus will begin his ministry there, and the Gospel will end when his disciples, full of joy and forever blessing God, will return to the Temple (*Luke* 24:50-53). Between the beginning and the end, however, much has happened, and much of it is foreshadowed in the episode of the finding of Jesus in the Temple.

The parents of Jesus attend Jerusalem for the feast of the Passover, as all pious Jews are commanded to do. The men and the women travel separately, again as pious Jews would travel from Nazareth to Jerusalem. But this leads to the apparent loss of their son. Something different is happening, as the boy "stayed behind in Jerusalem." They find him

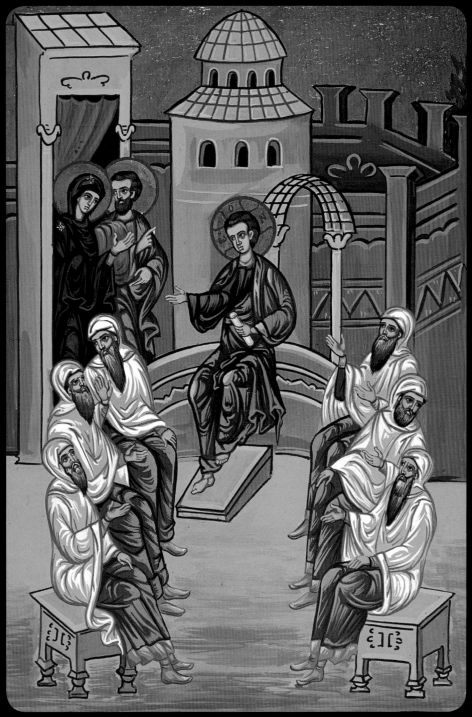

"after three days," just as he will return to his first disciples as the Risen One "after three days." The parents are amazed when they find him with the learned teachers in the Temple. He is where God dwells among his people, learning and sharing God's word with those specially trained to share it. In the face of their puzzlement and annoyance, Jesus himself utters the words that open his public ministry: "Did you not know that I must be in my Father's house?" Jesus' boyhood appears to be over. He is now answerable only to his Father, and he dwells in his house to hear his word that he might be the living word of his Father in the life-story that is about to begin. However, for the moment, he returns to Nazareth with his mother and Joseph, growing in wisdom and stature, only to be introduced by the voice of his cousin, John, the voice crying in the wilderness, in the very next episode (*Luke* 3:1-6). As with the events surrounding Jesus' birth (see *Luke* 2:19), so also with this revelation from her son, Mary treasures. Mary is unable to understand what God is asking of her. But she does not dismiss these mysteries. She treasures all these things in her heart, and waits for the fullness of God's saving action in and through her son.

The icon captures the centrality of Jesus in the scene, inside and at the centre of a smaller semi-circle that is set within the wider semi-circle of the Temple itself. The teachers are at his feet, and he is the one holding the scroll of the Law. But his mother and father are "outside" the semi-circle dominated by Jesus and the teachers. They are intruders, unable to understand what they have found. But Mary "treasures all these things in her heart."

Francis J. Moloney SDB

The Lord begins his mission as a teacher in his twelfth year, for this number of apostles was destined to preach of the faith (see *Matt* 10:1-2). Nor is it irrelevant that, as if forgetting his parents according to the flesh, Jesus who according to the flesh assuredly was filled with the wisdom

and grace of God, is found after three days in the Temple (*Luke* 2:43-46). This looks forward as a sign that he who was believed dead would rise again after three days from his triumphant experience of the passion (see *Matt* 26:61; 27:63).

In Christ there are two births: one from the Father, the other from his Mother. His birth from the Father has a uniquely divine character, while that from his Mother indicates his desire to embrace our pains and our human situation. All that takes place in Jesus that surpasses nature, time and human expectation does not come from his human faculties, but is the result of his divine authority. On one occasion, his Mother urges him to work a miracle (*John* 2:3), but his Mother is rebuked, as she asks for what is human. Here he is twelve years old, but at Cana he has disciples (see *John* 2:3). His Mother has learnt much from her son. As a grown man she can ask him for a miracle, while when he is a young boy she can only wait, wondering in her astonishment at his words (see *Luke* 2:47-48).

"And he came to Nazareth and was obedient to them" (*Luke* 2:51). The master of virtue quite naturally fulfilled all the obligations required by a good child. Do we wonder that he who is subject to his Mother also defers to his Father? Both these gestures of submission to his parents are not signs of weakness, but of respect.

Learn from Jesus this precious teaching, and be open to his devotion for his Father as a son. Learn the debt you owe your parents when you read that the Son was never separated from the Father, in will, action or time (see *John* 10:30).

Saint Ambrose, *Exposition of the Holy Gospel according to Saint Luke*, II, 63-66

The Baptism of Jesus in the Jordan
Mark 1:9-11

> [9] In those days Jesus came from Nazareth of Galilee and was baptised by John in the Jordan. [10] And just as he was coming up out of the water, he saw the heavens torn apart and the Spirit descending like a dove on him. [11] And a voice came from heaven, "You are my Son, the Beloved; with you I am well pleased."

As the time and the witness of John the Baptist come to a close, Jesus makes his first appearance. He comes from his hometown in Galilee, and associates himself with the baptism of John the Baptist. He also associates himself with the call to conversion that the Baptist symbolised by means on this immersion into the waters of the Jordan. But God's intervention in the human story takes a dramatic step forward in this encounter. The baptism of Jesus is accompanied by two signs: one is seen and the other is heard.

In the story of God's original creation, as it is told in Genesis, only the spirit of God hovered over the waters (*Gen* 1:2). After Adam's first sin of disobedience, human beings continue to fail, only to be supported by the God who made them. However, in the face of almost universal corruption, God decides to destroy the whole of his creation by means of a great flood. But he relents because of Noah and his family. The whole of the universe, in a situation of sin and turmoil, is destroyed, but Noah, his family, and all the animals escape. The first sign of the restoration of God's right order is a dove, sent out by Noah, who hovers over the waters (see *Gen* 6:1-8:12). The time has come for a new creation, as the world is once more in need of the saving action of God. The creative act that God will generate through Jesus, however, is definitive. To indicate that truth, the voice of God is heard from above. The Gospel story of Jesus begins with the good news that the time has come, and that God has sent his Son. God is well pleased with his Son, as he will do all that is asked of him, and through his obedience, resurrect the world from its fallen state, created by so much disobedience.

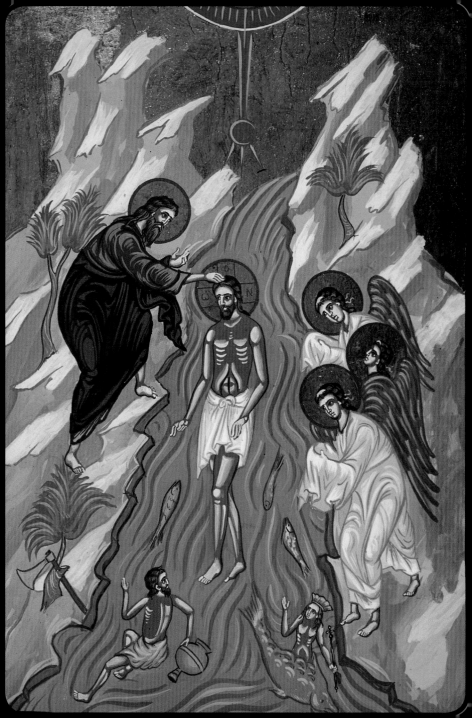

The icon portrays the action of the Baptist, along with the symbol of his preaching about the need for an axe to be laid to the root of the corrupt tree (Luke 3:9). The angels stand by, ready to accompany and nourish Jesus at the end of his period of temptation in the desert (*Mark* 1:13). But at the centre Jesus stands as the Lord of the waters that are subordinated to him, and the false gods that are washed away as Jesus appears on the scene – his first appearance as an adult.

Francis J. Moloney, SDB

With his trembling right hand, yet full of joy, John baptised the Lord. The Jewish people, who stood observing a certain distance away, wondered and said among themselves, "We thought perhaps that John was greater and better than Jesus. We thought that he excelled Jesus. Is not the baptism of John a witness to his superiority. Is it not true that the one who baptises is superior to the one who is baptised?" They murmured these things among themselves, all the while ignorant of God's saving plan. He who is the one Lord, the only Father of the Son, is the one who understands the depths and the perfection of this mystery. Only he gives new birth by means of Jesus' passion. As if correcting the mistaken questions asked by the Jewish people, he opens the heavens and sends the Holy Spirit upon Jesus in the form of a dove. In this way he presents the new Noah, Noah the creator, the just guide of the whole of nature in the midst of danger and wreckage.

Saint Gregory the Miracle Worker, *Homily on the Baptism of Christ.*

Those who receive the baptism of Christ do not seek the baptism of John; those who received the baptism of John sought the baptism of Christ… No baptism was necessary for Christ, but he received the baptism of a servant to encourage us to receive his baptism.

Saint Augustine, *Commentary on the Gospel of John*, V, 5

56

But why appear in the form of a dove? Gentle is that creature, and pure. In as much as the Spirit is "a Spirit of meekness" (*Gal* 5:22), he appears in this way. As well as that, this image reminds us of an ancient story. Once, when a universal wreckage had overtaken the world, and the human race was in danger of perishing, this creature appeared to indicate deliverance from the tempest, bearing an olive branch (*Gen* 8:11). The dove made known the good news of peace and goodness for the whole world. This was a type of things to come. The dove also appears, not bearing an olive branch, but pointing out to us our deliverer from all evils, and suggesting the hope for future grace. But the dove does not lead only one man (Noah) out of an ark. It now leads the whole world toward heaven. Instead of a branch of peace from an olive tree, the dove makes available the adoption of all the children of this world as children of God.

<div align="right">Saint John Chrysostom, Homily on the Gospel of Matthew, XII, 3</div>

10

The Temptation in the Desert
Matthew 4:1-11

> [1] Then Jesus was led up by the Spirit into the wilderness to be tempted by the devil. [2] He fasted forty days and forty nights, and afterwards he was famished. [3] The tempter came and said to him, "If you are the Son of God, command these stones to become loaves of bread." [4] But he answered, "It is written, 'One does not live by bread alone, but by every word that comes from the mouth of God.'" [5] Then the devil took him to the holy city and placed him on the pinnacle of the temple, [6] saying to him, "If you are the Son of God, throw yourself down; for it is written, 'He will command his angels concerning you,' and 'On their hands they will bear you up, so that you will not dash your foot against a stone.'" [7] Jesus said to him, "Again it is written, 'Do not put the Lord your God to the test.'" [8] Again, the devil took him to a very high mountain and showed him all the kingdoms of the world and their splendour; [9] and he said to him, "All these I will give you, if you will fall down and worship me." [10] Jesus said to him, "Away with you, Satan! for it is written, 'Worship the Lord your God, and serve only him.'" [11] Then the devil left him, and suddenly angels came and waited on him.

Many of the great figures from the pages of the Old Testament spent forty days fasting in the desert once they became aware of the immensity of the task that God had called them to, especially Moses and Elijah. Jesus repeats that symbolic experience in preparation for all that lies ahead of him. But there is another biblical moment that lies behind this encounter between Jesus and the devil. While in the desert God's people was tested. If Israel was to be the child of God, it had to live as God commanded (see *Deut* 6-8). The devil approaches Jesus, stating twice: "If you are God's Son" (*Matt* 4:3, 6). The Gospel claims that Jesus is the Son of God. The devil now wants to test whether or not this is true. The devil first tempts Jesus to show his power over creation: change stones to bread. But Jesus responds with the passage from the Scriptures where Israel was tested. Jesus will live by the word of God (see *Deut* 8:3), and not by the whims of the devil. As Jesus has used the word of God, the cunning devil also turns to the words of God, and recalls the promise of the angel's protection, found in *Psalm* 91:11-12. But Jesus again goes

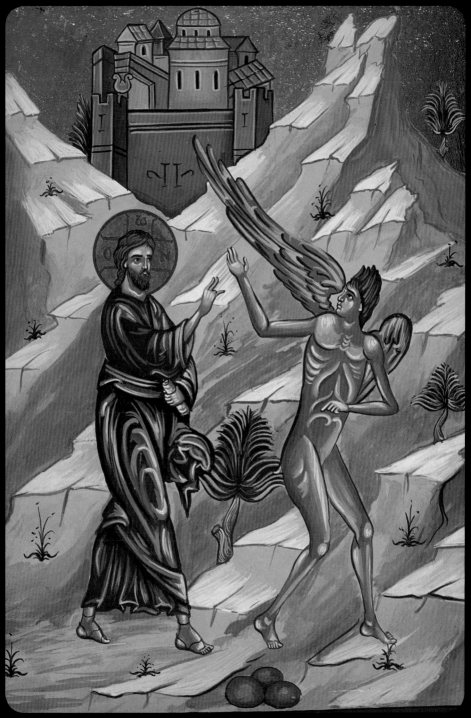

back to a passage from the testing of Israel (see *Deut* 6:16), and warns the devil not to tempt God. Finally, the devil abandons all reference to the word of God and asks the abominable: to bow down and worship evil. This is not only abominable, but impossible. The touchstone of Jesus' life and ministry are spelt out in Jesus' sharp expulsion of the devil from his presence: "You shall worship the Lord your God and him only shall you serve" (see *Deut* 6:13). The testing of God's son has come to a close, and the agents of God's care come and minister to him, a symbol of the oneness between Jesus and his Father.

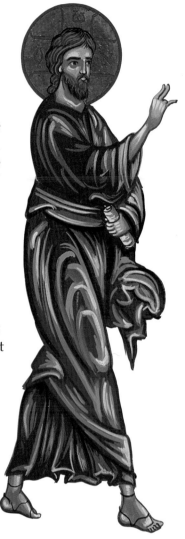

The icon provides the background for the temptation: the arid desert, the Temple and its pinnacle, the rocks to be turned into bread. At the centre of the icon Jesus and the devil meet face to face. As Jesus sends him away with a gesture of disdain, the devil's departing gesture also indicates that the encounter between goodness and evil has not come to an end. The gesture in the icon speaks out: "We will meet again!" Jesus will finally vanquish the devil only in the cruelty of the cross.

Francis J. Moloney SDB

The devil provokes Jesus with his temptations; he hunts him down to overcome him. This is the way the worst of all enemies begins his temptations, saying to the Lord: "If you are the Son of God, command these stones to become loaves of bread." Unaware of the merciful design of God and not knowing the mystery, he asks so that he might learn what he does not know. The expression that he uses is that of a person who wants to be freed from all doubt: "If you are the Son of God …"

The reason for his doubt lies in the fact that he sees before him an ordinary man whom, to his surprise, has been called the Son of God. He sees him as flesh and bone, but he has heard that this man has taken away the sin of the World. He wants to see clearly; he wants to understand what is really true in the things that he has heard. His question is made in fear and suspicion.

Saint Cromatius of Aquileia,
Commentary on the Gospel of Matthew, XIV, 2.

The freedom of the Holy Spirit can be found in the fact that he has led Jesus into the desert, and handed him over, in all his humanity, to the devil. The devil associates himself with Jesus and tempts him. None of this could have happened unless the Spirit had allowed it. In the devil there exists a suspicion that arises from fear, not a knowledge that comes from suspicion. The devil focuses his attention upon the forty days of fast. He knows the importance of the number forty: the number of days during which the waters of the abyss were turned back, the time of the exploration of the promised land, and during which the Law was written for Moses. The number of years that the People wandered in the desert, during which time they were called to live holy lives, like the angels. This period strikes fear in the devil and thus, in his temptation of someone whom he sees as a mere human being, he adopts a fearful approach. He had seduced Adam, and with his subtlety condemned him to death. It was only right that his perversity and his wickedness be overcome by this man for whom death and opposition were his glory. Before he tempted him the devil, jealous of the great gifts that God had given to a human being, was not able to recognise the presence of God in this man, Jesus.

Saint Hilary of Poitiers,
Commentary on the Gospel of Matthew, III, 1-2

61

The Wedding Feast at Cana in Galilee
John 2:1-11

> [1] On the third day there was a wedding in Cana of Galilee, and the mother of Jesus was there. [2] Jesus and his disciples had also been invited to the wedding. [3] When the wine gave out, the mother of Jesus said to him, "They have no wine." [4] And Jesus said to her, "Woman, what concern is that to you and to me? My hour has not yet come." [5] His mother said to the servants, "Do whatever he tells you." [6] Now standing there were six stone water jars for the Jewish rites of purification, each holding twenty or thirty gallons. [7] Jesus said to them, "Fill the jars with water." And they filled them up to the brim. [8] He said to them, "Now draw some out, and take it to the chief steward." So they took it. [9] When the steward tasted the water that had become wine, and did not know where it came from (though the servants who had drawn the water knew), the steward called the bridegroom [10] and said to him, "Everyone serves the good wine first, and then the inferior wine after the guests have become drunk. But you have kept the good wine until now." [11] Jesus did this, the first of his signs, in Cana of Galilee, and revealed his glory; and his disciples believed in him.

In the Gospel of John, the changing of the water into wine at Cana is the first action in Jesus' public ministry. He has called his first disciples and they have shown the beginnings of belief (*John* 1:35-51). But they must go further, and it is the Mother of Jesus who shows the way. Notice that she is the first person mentioned in the story, and this is the first time she appears in the Gospel of John. She sees the problem of the lack of wine, a serious problem in a society where one's honour was measured by the success of such public events as a wedding. She calls Jesus' attention to it, only to receive a reproof from her son. But despite his strange words to her, she turns to the attendants and uses words that she continues to repeat to all followers of Jesus down through the centuries: "Do whatever he tells you." The waters used for the ritual washings in Judaism are transformed into a rich wine, as the attendants follow the command of the Mother of Jesus. They do what Jesus tells them to do. For the first time, the glory of Jesus shines forth, and the disciples begin to deepen their faith in Jesus. Much more will be asked of them.

The icon has deliberately focused upon the intervention of the Mother of Jesus. It is shaped by a foreground made up of the attendants and the water jars, and its main focus, the people around the table. The crowned husband and his wife hold their glasses. Concern is on their faces. One of the guests looks into the bottom of an empty glass. In that moment, the Mother of Jesus turns to her son and whispers: "They have no wine." We know what follows, and the icon triggers our imagination, drawing us into a response to the words that the Mother of Jesus will say to the attendants: "Do whatever he tells you." The disciples are not in the icon, as we are the disciples, anticipating the revelation of the glory of Jesus and believing in him.

<div align="right">Francis J. Moloney, SDB</div>

The Lord was invited and came to a wedding. What wonder that he who came to that house for a wedding also came to this world for a wedding? For if he did not come for a wedding, he does not have a bride here.

Therefore he has a bride here whom he has redeemed by his blood and to whom he has given the Holy Spirit as a pledge. He wrested her from enslavement to the devil, he died for her sins. He rose again for her justification. What other bridegroom would offer such great things to his bride?

For the Word was the bridegroom, and human flesh was the bride; and both are the one Son of God and likewise the Son of Man. That womb of the Virgin Mary where he became the head of the Church was his bridal chamber; he came forth from there like the bridegroom from his bridal chamber, as Scripture foretold: "And he, as a bridegroom coming forth from his bridal chamber, has rejoiced as a giant to run the way" (*Psalm* 18:6). He came forth from the bridal chamber like a bridegroom; and having been invited, he came to the wedding.

<div align="right">Saint Augustine, *Commentary on the Gospel of John*, VIII, 4</div>

Therefore our Lord Jesus Christ changed water into wine; and what was tasteless acquires taste, what was not intoxicating, intoxicates. He had ordered the water poured out of them and put in wine from the secret hollows of creation from which he also created the bread when he satisfied so many thousands.

He could have also, after the water had been poured out, poured in wine; but if he had done this, he would have seemed to have repudiated the ancient Testament. But when he turned the water itself into wine, he showed us that the ancient Scripture comes from him too; for by his order the jars were filled. This Scripture too is indeed from the Lord; but it has no taste if Christ should not be understood in it.

Saint Augustine, *Commentary on the Gospel of John*, IX, 5

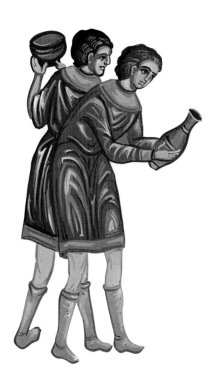

Jesus' Meeting with the Samaritan Woman
John 4:4-15

> [4] But he had to go through Samaria. [5] So he came to a Samaritan city called Sychar, near the plot of ground that Jacob had given to his son Joseph. [6] Jacob's well was there, and Jesus, tired out by his journey, was sitting by the well. It was about noon. [7] A Samaritan woman came to draw water, and Jesus said to her, "Give me a drink." [8] (His disciples had gone to the city to buy food.) [9] The Samaritan woman said to him, "How is it that you, a Jew, ask a drink of me, a woman of Samaria?" (Jews do not share things in common with Samaritans.) [10] Jesus answered her, "If you knew the gift of God, and who it is that is saying to you, 'Give me a drink,' you would have asked him, and he would have given you living water." [11] The woman said to him, "Sir, you have no bucket, and the well is deep. Where do you get that living water? [12] Are you greater than our ancestor Jacob, who gave us the well, and with his sons and his flocks drank from it?" [13] Jesus said to her, "Everyone who drinks of this water will be thirsty again, [14] but those who drink of the water that I will give them will never be thirsty. The water that I will give will become in them a spring of water gushing up to eternal life." [15] The woman said to him, "Sir, give me this water, so that I may never be thirsty or have to keep coming here to draw water."

Jesus journeys into the world outside Judaism when he stops at the well at Sychar in Samaria. He challenges accepted custom by speaking to a Samaritan woman. He opens the conversation, asking her to provide drink for him. The disciples have left to buy food in the village, and thus the two of them converse alone. The woman is shocked that a Jewish man would speak to her, but Jesus provides the key to his desire to speak to the Samaritan woman, a representative of the world outside Israel, when he tells her: "If you knew the gift of God, and who it is that is speaking to you." He then explains to the woman "the gift of God." To someone who comes to this well every day to collect ordinary water from a well, he promises water that will quench all thirst, a water that wells up from deep inside the believer. But this "gift of God" is beyond the understanding of the woman. She can only think of ordinary wells, and asks for Jesus' gift so that she will not have to come back day after

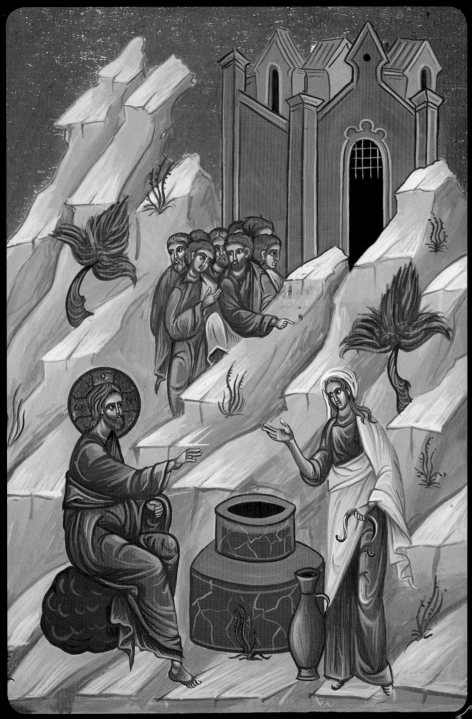

day for everyday water. She cannot believe that Jesus can surpass the gift of Jacob whose family and flocks had opened the well in the distant past. But Jesus will persevere with the women, and then with her fellow-villagers. She will eventually ask if this man can be the Messiah (*John* 4: 25-26) and the villagers, led to Jesus by the woman, will confess, "We believe that he is the Saviour of the world" (*John* 4: 42).

The well is at the centre of the icon and the village forms the background. The dialogue is under way. But Jesus' hand points to the truth of the gift that he will give, and who it is that gives this gift. The woman's palm faces upwards, in a receptive mode. People from the village in the background will eventually come to understand both. But between the well and the village, the puzzled disciples show their limitations. They are surprised that he is talking to a Samaritan woman, but none of them will voice their concerns (see *John* 4:27).

Francis J. Moloney, SDB

He asks for a drink, and he promises a drink. He is in need as one who is going to receive; and he is rich as one who is going to satisfy. "If you knew," he says, "the gift of God." The gift of God is the Holy Spirit. But he is still speaking obscurely to the woman and entering little by little into her heart. Perhaps he is already teaching. For what is sweeter and kinder than this exhortation: "If you knew the gift of God and knew who he is who says to you, 'Give me a drink,' you perhaps would ask, and he would give you living water." Thus far he keeps her in suspense.

Saint Augustine, *Commentary on the Gospel of John*, XV, 12

Yet the woman, left in suspense, says, "Sir, you have nothing to draw with, and the well is deep". See how she understood living water, namely the water that was in the spring. You want to give me living water, and I am carrying the means to draw and you are not. Here is living water; how are you going to give it to me? Although misunderstanding and knowing carnally, she is knocking so that the teacher may open what is closed. She is knocking with ignorance, not with zeal; she is still to be pitied, yet to be instructed.

Saint Augustine, *Commentary on the Gospel of John*, XV, 13

"Oh would that I had found," you said, "some high and lonely mountain! For I believe, because God is on high, he hears me from a high place." Because you are on a mountain, do you think that you are near God and that you are heard quickly, as if shouting from nearby? He dwells on high but "he looks on the lowly" (*Psalm* 137:6). The Lord is near. To whom? Perhaps to the high? "To those who are contrite of heart" (*Psalm* 33:19). It is a wondrous thing. He both lives on high and draws near to the lowly. He sees the proud from afar; the higher they seem to themselves, so much the less does he approach them. Did you therefore seek the mountain? Come down that you may reach it.

The valley is in the lowland. Try to be recollected within yourself. And if, perhaps, you seek some high place, some holy place, present yourself to God as the temple that dwells in you. "For the temple of God is holy, which you are" (*1 Cor* 3:17). Do you want to pray in a temple? Pray in yourself. But first be a temple of God, so that he might hear you praying in his temple.

Saint Augustine, *Commentary on the Gospel of John*, XV, 25

13

The Healing of the Gerasene Demoniac
Mark 5:1-2, 6-15, 18-19

¹ They came to the other side of the sea, to the country of the Gerasenes. ² And when he had stepped out of the boat, immediately a man out of the tombs with an unclean spirit met him. [...] ⁶ When he saw Jesus from a distance, he ran and bowed down before him; ⁷ and he shouted at the top of his voice, "What have you to do with me, Jesus, Son of the Most High God? I adjure you by God, do not torment me." ⁸ For he had said to him, "Come out of the man, you unclean spirit!" ⁹ Then Jesus asked him, "What is your name?" He replied, "My name is Legion; for we are many." ¹⁰ He begged him earnestly not to send them out of the country. ¹¹ Now there on the hillside a great herd of swine was feeding; ¹² and the unclean spirits begged him, "Send us into the swine; let us enter them." ¹³ So he gave them permission. And the unclean spirits came out and entered the swine; and the herd, numbering about two thousand, rushed down the steep bank into the sea, and were drowned in the sea. ¹⁴ The swineherds ran off and told it in the city and in the country. Then people came to see what it was that had happened. ¹⁵ They came to Jesus and saw the demoniac sitting there, clothed and in his right mind, the very man who had had the legion; and they were afraid. [...] ¹⁸ As he was getting into the boat, the man who had been possessed by demons begged him that he might be with him. ¹⁹ But Jesus refused, and said to him, "Go home to your friends, and tell them how much the Lord has done for you, and what mercy he has shown you."

Jesus comes to the Gentile town of Gerasa, on the other side of the Sea of Galilee. There are two external signs of the presence of all that is not holy. The first is the terrible condition of the possessed man, bound with chains and screaming out hatred against "Jesus, Son of the Most High." The second is the presence of the "great herd of swine," unclean animals in the Jewish tradition. Jesus takes control of the legion of demons that possess the man, and sends them into the swine. They plunge into annihilation in the depths of the sea, a place of terror and nothingness. In this way the man is cleansed of the evil that has taken possession of him, and the land is cleansed of the evil that dwells in it, symbolised by the presence of the swine. Jesus' coming to Gerasa brings wholeness to the man and holiness to the land upon which he stands. But such

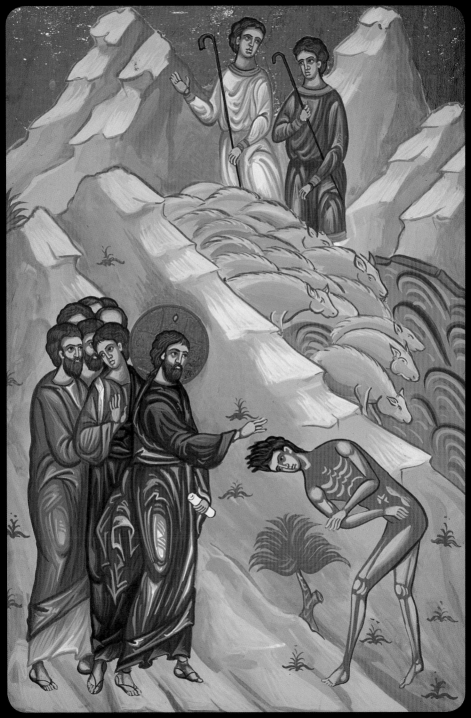

wholeness and holiness are uncomfortable. The people from the village ask him to leave their land. But the cured man wishes to "be with Jesus" as his follower and disciple (see *Mark* 3:14). He will be Jesus' disciple, not by being with him, but by obedience to his word. He is to go back to his own town and announce the Gospel (the good news) of what the Lord has done for him in and through Jesus.

All the major elements of this miracle are caught in the icon. In the foreground Jesus cures the unshackled man who bows before him, beginning his life as a disciple. The swine plunge to their destruction into the abyss of the sea. But the swineherds look at one another in anger, with a hand raised in shock. Jesus' powerful healing and sanctifying presence will not be tolerated by all.

<div align="right">Francis J. Moloney, SDB</div>

Look how the devil who promised all the honours of a kingdom is found dwelling in stinking graves amidst decomposing corpses (see *Mark* 5:3; *Luke* 8:27).

At the command of Christ the punishments have been reversed. Earlier a man without fault was tormented by the wickedness of the devil; now a man is set free, but the devil pays the penalty. The flesh is healed, but the unclean spirit lies powerless and prostrate. "He ran up and did him homage" (*Mark* 5:6). What is this, O devil? The one whom you tried to make fall with your three temptations, whom you tried to trap into worship of you by means of the promise of a kingdom, you should now, trembling and pitiful, fall on your face and adore.

<div align="right">Saint Peter Chrysologus, *Sermons*, XVII, 2</div>

Come out of the human being and enter the swine; enter the animals and go where you will: go into hell. But leave the human being who belongs exclusively to me. Come out of the human being; I do not want you taking possession of the human being because it is an offence against me that you take your place in the human being where I must take my place. I am the one who took on the human condition and dwelt among men. This flesh that you wish to possess is part of my flesh. Come out of the human being!

<div align="right">Saint Jerome, *Homilies on the Gospel of Matthew*, 2</div>

Look too at Legion: when in anguish he begged, our Lord permitted and allowed him to enter the herd. Respite did he ask for, without deception, in his anguish. And our Lord in his kindness granted this request.

Encouraged by the words I had heard, I knelt down and wept there, and spoke before our Lord: "Legion received his request from you without any tears; permit me, with my tears, to make my request. Grant that I may enter, instead of that herd, the Garden so that in Paradise I might sing of it's planter's compassion.

<div align="right">Saint Ephrem, Hymns of Paradise, XII, 8-9</div>

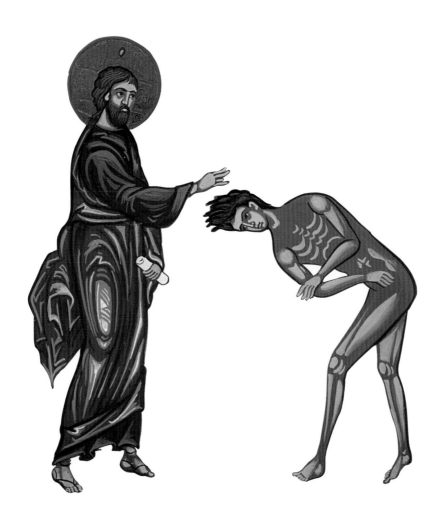

14

The Healing of the Daughter of Jairus
Mark 5:22-23, 35-42

²² Then one of the leaders of the synagogue named Jairus came and, when he saw him, fell at his feet ²³ and begged him repeatedly, "My little daughter is at the point of death. Come and lay your hands on her, so that she may be made well, and live." […] ³⁵ While he was still speaking, some people came from the leader's house to say, "Your daughter is dead. Why trouble the teacher any further?" ³⁶ But overhearing what they said, Jesus said to the leader of the synagogue, "Do not fear, only believe." ³⁷ He allowed no one to follow him except Peter, James, and John, the brother of James. ³⁸ When they came to the house of the leader of the synagogue, he saw a commotion, people weeping and wailing loudly. ³⁹ When he had entered, he said to them, "Why do you make a commotion and weep? The child is not dead but sleeping." ⁴⁰ And they laughed at him. Then he put them all outside, and took the child's father and mother and those who were with him, and went in where the child was. ⁴¹ He took her by the hand and said to her, "Talitha cum," which means, "Little girl, get up!" ⁴² And immediately the girl got up and began to walk about (she was twelve years of age). At this they were overcome with amazement.

Jairus presents himself to Jesus in an act of faith. He has trust in what Jesus can do for his daughter who is close to death. But his worst fears come true as they approach the house. The child is already dead. In the midst of the commotion of the wailing that traditionally accompanied death, Jesus tells his disciples, the child's parents and the professional wailers, that they are wrong to see the child as deceased. She is only sleeping. Closing out all the public, he draws the parents and his chosen disciples into the room with the girl, takes her by the hand and speaks to her with affection: *Talitha kum*. "My dearest little one, stand up." She rises, walks, and everyone is amazed. The amazement comes from the fact that Jesus has raised this young woman from death. But there is more to it. He has taken a twelve year old girl by the hand and spoken to her as an intimate friend. This is not the way a respected teacher and miracle worker should act in a society where the relationships between women and men were so controlled. But Jesus breaks through the false

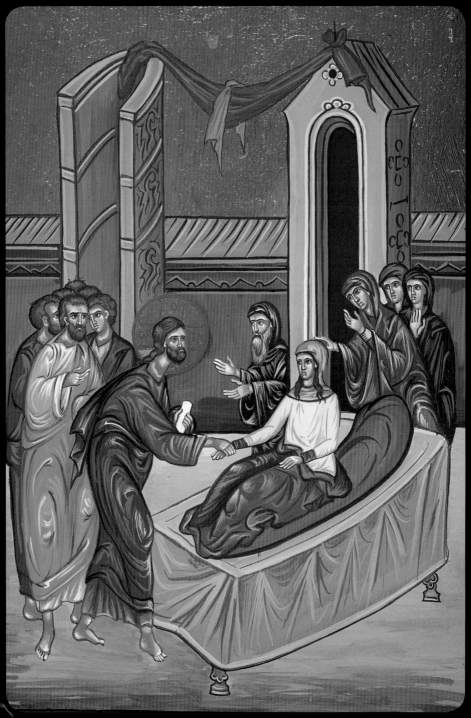

frontiers set up by custom and taboo when it is a question of restoring life and wholeness to those in need.

The icon focuses on the crucial elements in this story. At the centre of the icon is the joining of the hands of Jesus and the girl. Notice also that she is not depicted as a baby. She is a young woman. The gaze of Jesus, however, is not fixed upon the girl, but upon Jairus. The man of faith, and Jesus who rewards such faith, are at one as Jesus responds to his request. Other characters form the background: Peter, James and John stand behind Jesus, and two other surprised visitors stand behind the mother. The miracle itself flows from the elements portrayed at the icon's centre: the relationship between Jesus and Jairus, and Jesus' touch that gives life to Jairus' daughter.

Francis J. Moloney, SDB

Jairus does not tell Jesus how the sick person should be cured, but only asks that she be cured. But since he was a synagogue ruler, he had knowledge of the Law. He had read that while everything else had been created by the Word, the human being had been fashioned by the hand of God.

Saint Peter Chrysologus, *Sermons*, XXXIII, 3

"He allowed no one to follow him except Peter and James, and John the brother of James."

Someone may wonder and ask: Why are these apostles always chosen and the others sent away? Even when he was transfigured on the mountain, these three were with him. Yes, three are chosen: Peter, James and John. In the first place there is the mystery of the Trinity in this number, in itself a sacred number.

Thus, Peter, upon whom the Church is to be built (see *Matt* 16:18), James, the first of the apostles crowned with martyrdom (see *Acts* 12:2), and John, who initiates the state of virginity, are chosen.

<div align="right">Saint Jerome, Homilies on the Gospel of Mark, 3</div>

He arrived at the house and found that the expected proper rituals for a funeral had already been prepared. He said to the people: "Do not weep, because the girl is not dead, but asleep" (*Mark* 5:39). He told the truth: she slept, but only for the one who was able to raise her from that sleep. Waking her, he returned her to her parents.

<div align="right">Saint Augustine, Discourses, XCVIII, 4</div>

Before my sermon discloses the mystery of the Gospel's meaning, it is fitting at this point to speak a little bit about the suffering that parents assume and endure out of their affection and love for their children.

What tragedy! Why are children so ignorant of such love? Why, not understanding, do they make no effort to return the love of their parents? Nevertheless, the devotion of parents remains constant because whatever parents expend on their children, God, the Parent of all, will repay them.

<div align="right">Saint Peter Chrysologus, Sermons, XXXIII, 2</div>

15

The Beheading of John the Baptist
Matthew 14:3-12

[3] For Herod had arrested John, bound him, and put him in prison on account of Herodias, his brother Philip's wife, [4] because John had been telling him, "It is not lawful for you to have her." [5] Though Herod wanted to put him to death, he feared the crowd, because they regarded him as a prophet. [6] But when Herod's birthday came, the daughter of Herodias danced before the company, and she pleased Herod [7] so much that he promised on oath to grant her whatever she might ask. [8] Prompted by her mother, she said, "Give me the head of John the Baptist here on a platter." [9] The king was grieved, yet out of regard for his oaths and for the guests, he commanded it to be given; [10] he sent and had John beheaded in the prison. [11] The head was brought on a platter and given to the girl, who brought it to her mother. [12] His disciples came and took the body and buried it; then they went and told Jesus.

The Gospel story of the execution of John the Baptist prepares the way for the execution of Jesus. John the Baptist is Jesus' forerunner in this, as he was of his first appearance. John speaks out boldly against Herod's sinfulness, and he is arrested for his courageous preaching of God's Law. But Herod is unable to put him to death because "the crowd regarded him as a prophet." Jesus boldly proclaimed the imminent coming, and the presence, of the Kingdom of God, and he was imprisoned by Pilate. During his trial, Pilate hesitates to hand Jesus over for execution because he is aware of the esteem in which he is held by the people. John the Baptist is eventually slain because a vain king is threatened by Herodias who asks for it, and he is afraid that his reputation might be at stake if he does not keep his rash promise. Jesus is also admired by Pilate, and he recognises that Jesus is innocent, but he gives in and allows the crucifixion because the leaders of Israel threaten that they will make known his lack of allegiance to Rome. But there is an important difference at the end of the story. The story of John the Baptist comes to an end when his disciples take his body and lay it in a tomb. The disciples of Jesus also lay his body in a tomb, but that is not the end of the story of Jesus. They will eventually find that the tomb is empty.

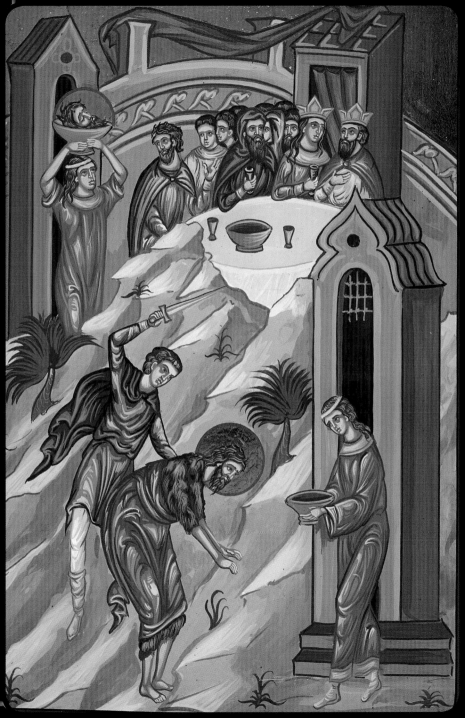

The icon tells the story in two carefully constructed sections. At the top of the icon the banquet table is set to honour Herod, and Herodias gazes at him in wicked collusion. In the foreground John is beheaded and the girl-dancer waits, in sadness, for the head so that she can return it to the celebration, an image found at the top left of the icon. As the ministry of Jesus Christ develops, that of John the Baptist diminishes. But even in death he prepares the way of the Lord.

Francis J. Moloney, SDB

Herod, having laid hold of John, bound him and put him in prison, did not dare to slay him outright and to take away the prophetic word from the people. But the wife of the king of Trachonitis – who is a figure of evil opinion and wicked teaching – gave birth to a daughter with a name similar to hers. The daughter's movements, seemingly harmonious, pleased Herod […]. They became the cause of there being no longer a prophetic head among the people. […] The dancing of Herodias is the opposite of a holy dancing. Those who have not danced the holy dance of God will be reproached when they hear the words, "We piped unto you, and you did not dance" (*Matt* 11:17).

When the lawless word reigns over them, they dance so that their movements please that word.

But thanks be to God, even if the grace of prophecy was taken from the people, a grace greater than all that was poured forth [...] by our saviour Jesus Christ, who became "free among the dead" (*Psalm* 87:6); for "though he was crucified for our weakness, yet he lives through the power of God" (*2 Cor* 13:4).

The prophet is beheaded because of an oath. But true devotion to duty would have been found in breaking the oath rather than in keeping it. The charge of rashness that can be levelled because of the taking of an oath and then having to break it is not the same as the guilt that flows from the execution of a prophet.

And notice, further, that Herod puts John to death not openly, but in the prison, secretly. There is no open denial of the prophecies of God. They are denied in secret, and in so doing those who deny stand convicted of disbelieving the prophetic word. For as "if they had believed Moses they would have believed Jesus" (*John* 5:46), so also if they had believed the prophets they would have received him who had been the subject of prophecy. But disbelieving him they also disbelieve them, and they imprison and mutilate the prophetic word. They regard it as dead and beheaded, in no way life-giving, as they do not understand it. But we have the life provided by Jesus, the fulfilment of the prophecy concerning him which said, "not a bone shall be broken" (*John* 19:36; see *Exodus* 12:46).

<div align="right">Origen, Commentary on the Gospel of Matthew, X, 22</div>

16

The Transfiguration
Matthew 17:1-9

[1] Six days later, Jesus took with him Peter and James and his brother John and led them up a high mountain, by themselves. [2] And he was transfigured before them, and his face shone like the sun, and his clothes became dazzling white. [3] Suddenly there appeared to them Moses and Elijah, talking with him. [4] Then Peter said to Jesus, "Lord, it is good for us to be here; if you wish, I will make three dwellings here, one for you, one for Moses, and one for Elijah." [5] While he was still speaking, suddenly a bright cloud overshadowed them, and from the cloud a voice said, "This is my Son, the Beloved; with him I am well pleased; listen to him!" [6] When the disciples heard this, they fell to the ground and were overcome by fear. [7] But Jesus came and touched them, saying, "Get up and do not be afraid." [8] And when they looked up, they saw no one except Jesus himself alone. [9] As they were coming down the mountain, Jesus ordered them, "Tell no one about the vision until after the Son of Man has been raised from the dead."

Once Jesus set his face towards Jerusalem, he begins to instruct his disciples that they are to follow a Messiah who is also a suffering, crucified and risen Son of Man. Who can this man be? The answer is provided for Peter, James and John in the episode of the Transfiguration. Jesus' external appearance takes on the splendour of a heavenly being. He converses with Moses and Elijah. They are generally regarded as representing the whole of the Scripture: the giver of the Law (Moses) and the first of all the Prophets (Elijah). But they were also two figures regarded by Jesus' contemporaries as men of God who did not die, but who were assumed into heaven. For this reason they are also with Jesus in conversation, as death will not be the end of Jesus' story. Well pleased with this wonderful experience, Peter suggests that they build three tents so that this moment of encounter with the heavenly can be preserved. But a voice from heaven announces: "This is my Son, the Beloved; with him I am well pleased; listen to him." The disciples, now aware that this man is also the one who is calling them to follow him to Calvary, fall to the ground in fear. It is very hard to listen to a Son of God who is also the Son of Man. But Jesus calls to them telling them not to fear. However,

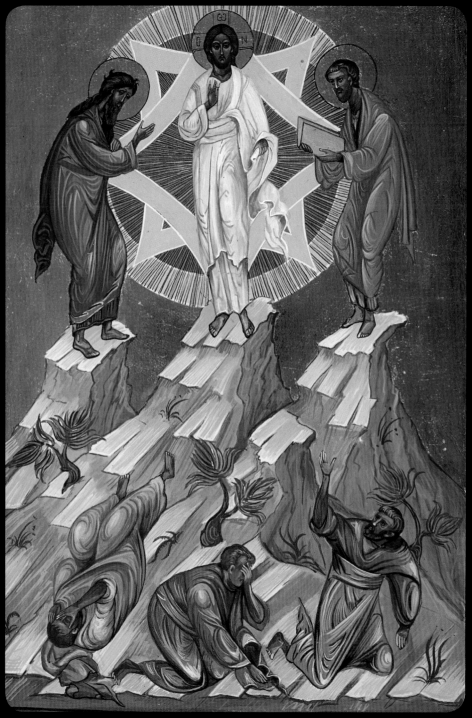

the destiny of Jesus cannot be altered, and they are to be part of it. They are to tell of this revelation of the true identity of Jesus "after the Son of Man has been raised from the dead."

The icon attempts to capture the impossible by means of the solar disk, sometimes elliptical and at other times circular, inside which convex diamond shapes move. At the centre of this pattern stands the luminous figure of the transfigured Jesus. Moses stands to the left of Jesus, holding the Law; Elijah is on the right, with his hand outstretched in a gesture that recalls his prophetic teaching. But the disciples have collapsed at the foot of the icon. They are unable to cope with what is said of Jesus, and what will be asked of them.

Francis J. Moloney, SDB

In six days, the perfect number, the whole world – the perfect work of art – was made. Jesus transcends all the things of the world by attending not to the things which are seen, for they are temporal, but to the things which are not seen – and only the things which are not seen – because they are eternal. For this reason "after six days Jesus took with him" only Peter, James and John. If any one of us wishes to be taken by Jesus, and led up by him on to the high mountain, and be deemed worthy of beholding his transfiguration, let us pass beyond the six days, no longer gazing upon the things which are seen, no longer loving the world, nor the things of the world, nor longing for any worldly pleasures. When we have passed through the six days, as we have said, we will keep a new Sabbath, rejoicing on the lofty mountain, because we see Jesus transfigured before us. The Word has different forms, as he appears to each as is expedient for the beholder, and is manifested to no one beyond the capacity of the beholder.

Origen, *Commentary on the Gospel of Matthew*, XII, 36

If you wish to see the transfiguration of Jesus before those who ascended the high mountain with him, behold with me Jesus in the Gospels. More simply, one might say, behold Jesus known "according to the flesh" by those who do not ascend the mountain but are uplifted by his works and words. They attain the lofty mountain of wisdom. Jesus is then no longer known according to the flesh, but in his divinity by means of all the Gospels, read and understood according to the understanding of each person. Before such a believer is Jesus transfigured, and not before others here below. When he is transfigured his face also shines as the sun, so that he may be manifested to the children of light, who have put off the works of darkness and put on the armour of light. They are no longer the children of darkness or night. They have become the sons of day, and walk honestly as in the day. Once manifested, the transfigured Jesus will shine for them not simply as the sun, but he will be for them the sun of righteousness.

Origen, *Commentary on the Gospel of Matthew*, XII, 37

The Prayer in the Temple
Luke 18:10-14

[10] "Two men went up to the temple to pray, one a Pharisee and the other a tax collector. [11] The Pharisee, standing by himself, was praying thus, 'God, I thank you that I am not like other people: thieves, rogues, adulterers, or even like this tax collector. [12] I fast twice a week; I give a tenth of all my income.' [13] But the tax collector, standing far off, would not even look up to heaven, but was beating his breast and saying, 'God, be merciful to me, a sinner!' [14] I tell you, this man went down to his home justified rather than the other; for all who exalt themselves will be humbled, but all who humble themselves will be exalted."

In the Gospel of Luke, Jesus and his disciples make a long journey from Galilee to Jerusalem (see *Luke* 9:51-19:44). Just before his arrival in Jerusalem, the Temple city, he tells a parable about two men who pray in the Temple. Jesus is preparing his disciples for a proper understanding of a relationship with God, traditionally associated with the Temple, the dwelling place of God among his people. The two men are not named, but we are told what they do: one is a Pharisee and the other is a Tax Collector. We know what they stand for. The Pharisee is a person who adheres strictly to the best traditions of Israel, as they are found in the Law and the Prophets. He is a righteous man. The Tax Collector has sold his soul to the foreign power that has taken possession of the holy land of Israel, and exacts taxes from his fellow Israelites that go to Rome. In doing so, he probably exacts more from the people than the Romans demand, so that he can conduct a business that generates a profit. The prayer of the Pharisee does not make any claims that are not true. He tells the God dwelling in the Temple how observant he is. His arrogance, however, emerges in his claim to be "not like other people … or even like this Tax Collector." The fact that he is aware of the presence of the Tax Collector in the Temple shows that he is displaying his virtue to all and sundry. The Tax Collector tells no lies either. He describes himself exactly as he is: "a sinner." Fundamental to all prayer is an openness to what God can do. Confidence in one's own virtues does not manifest a

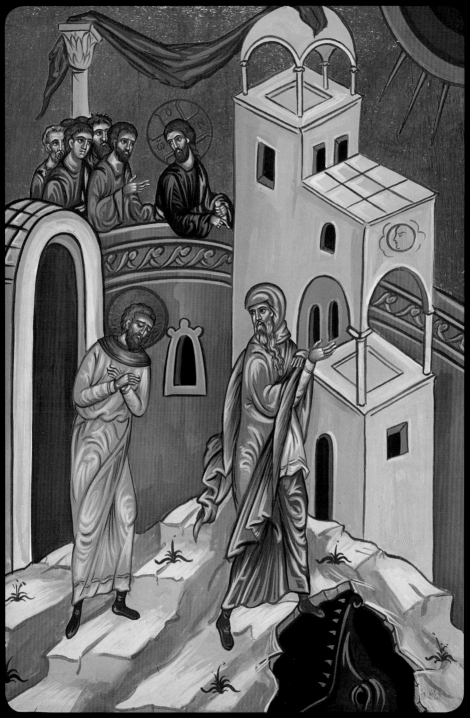

preparedness to receive what God has to give. The Pharisee says a prayer that asks for nothing, but only thanks God because he is so virtuous, unlike others; the Tax Collector asks for the greatest of all graces: "God, be merciful to me." God's saving presence can only act in the hearts and lives of those who see that they need it. For this reason, the Tax Collector goes home justified, while the Pharisee does not.

The Gospel message is eloquently caught in the icon. The fact that this is a parable that Jesus tells to instruct his disciples is portrayed by the presence of Jesus pointing to the Pharisee as he instructs his disciples in the upper panel of the image. The Pharisee is well dressed, and looks back in arrogance to the Tax Collector. But his foot is poised over the hellish abyss into which he is about to tumble. The Tax Collector bows in prayer with his hands crossed in a sign of repentance. Only Jesus and the Tax Collector are crowned with a halo, the sign of their holiness.

<div align="right">Francis J. Moloney, SDB</div>

Why do the demons wish to commit acts of gluttony, impurity, avarice, wrath, resentment and the other evil passions in us? Here is the reason – so that the spirit in this way should become dull and consequently render us unfit to pray. For when our irrational passions are thriving we are not fit to pray and to seek the word of God

<div align="right">Saint Evagrius of Pontus, On Prayer, 50</div>

If you are a theologian, you truly pray. If you truly pray you are a theologian.

When your spirit withdraws, little by little, from the flesh because of your ardent longing for God, and turns away from every thought that derives only from the senses, memories or temperament, steadily filling you with reverence and joy, then you can be sure that you are drawing near to that country whose name is prayer.

The Holy Spirit takes compassion on our weakness, and though we are impure he often comes to visit us. If he should find our spirit praying to him out of love for the truth, he descends upon it and dispels the army of false thought and plans that beset it. He urges it on to love of the works of spiritual prayer.

<div align="right">Saint Evagrius of Pontus, On Prayer, 60, 61,62</div>

Pray not as the Pharisee but as the publican in the holy place of prayer, so that you also may be justified by the Lord.

Strive to avoid praying against anyone in your prayer. Do not destroy what you have been building up by defiling your prayer.

Saint Evagrius of Pontus, *On Prayer*, 102, 103

The value of prayer is found not merely in its quantity but in its quality (see *Luke* 18:10). This is made clear by those two men who entered the temple, and also by the saying: "When you pray do not do a lot of empty chattering…" (*Matt 6:7*).

Saint Evagrius of Pontus, *On Prayer*, 151

18

The Entrance into Jerusalem
John 12:12-16

[12] The next day the great crowd that had come to the festival heard that Jesus was coming to Jerusalem. [13] So they took branches of palm trees and went out to meet him, shouting, "Hosanna! Blessed is the one who comes in the name of the Lord — the King of Israel!" [14] Jesus found a young donkey and sat on it; as it is written: [15] "Do not be afraid, daughter of Zion. Look, your king is coming, sitting on a donkey's colt!" [16] His disciples did not understand these things at first; but when Jesus was glorified, then they remembered that these things had been written of him and had been done to him.

Two themes run through this account of Jesus' entry into Jerusalem. A great crowd present in Jerusalem for the celebration of the Passover gathers because they have heard that Jesus is coming to Jerusalem. However, immediately before this gathering, the leaders of Israel have decided that Jesus must die for the nation, and the Evangelist has added: "Not for the nation only, but to gather into one the children of God who are scattered abroad" (*John* 11:52). The people bring palm fronds to wave as they greet Jesus, but this was the greeting the people gave to the great military leader, Judas Maccabeus, when he conquered the Syrian armies and took possession of Jerusalem (see 1 *Macc* 13:51). Does Jesus want to be greeted as a military leader? The crowd expresses its hope that he will be. They greet him as the one coming in the name of the Lord: "the King of Israel." They are looking for a Davidic king, a conqueror. But Jesus wordless response is to take a humble animal, a young donkey, and ride into Jerusalem in fulfillment of the Prophet Zechariah's words that a humble king, who would be pierced and slain, will come riding on a donkey's colt (*Zech* 9:9). Jesus' actions do not meet the crowd's expectations, and the disciples find this confusing. However, after Jesus has been glorified, after his death and resurrection, the disciples recalled that what had been done to him in his death and resurrection would fulfill the promises of the Prophet.

The icon catches this dual message. The disciples follow, with wondering looks on their faces, and glance at one another. The people of

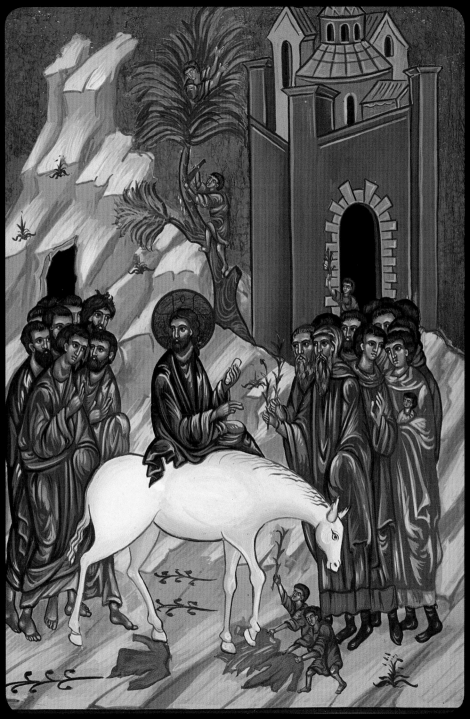

the city come out of the city gate with their fronds in their hands. But in the background, under the guise of a tree, the shadow of the cross hangs over the scene. Slightly further back is an empty tomb in the side of a hill. It is through crucifixion and resurrection that Jesus will be king … not through popular acclaim for an expected military Messiah.

<div align="right">Francis J. Moloney, SDB</div>

After the Lord had raised up the man dead for four days, to the astonishment of the Jews, some of them believed because of the sight, and others did not because of their envy. The good fragrance is life for some and death for others. All this happened after he had reclined at table in the house together with Lazarus who resumed his place at table, the one who had been raised up from the dead; after the perfume was poured over his feet and the house filled with its fragrance. I invite you now, my beloved people, to direct your thoughts to how much fruitfulness appeared from his preaching before the Lord's passion and to how great a flock of sheep of the house of Israel, from those who had been lost, heard the voice of the shepherd.

<div align="right">Saint Augustine, Commentary on the Gospel of John, Tractate LI, 1</div>

The palm branches are praises, signifying victory; for the Lord was able to overcome death by dying and by the trophy of the cross was about to triumph over the devil, the prince of death.

<div align="right">Saint Augustine, Commentary on the Gospel of John, Tractate LI, 2</div>

The crowd was shouting these praises to him: "Hosanna! Blessed is he who comes in the name of the Lord, the king of Israel!" What a crucifixion of the mind the leaders of the Jews would suffer when so great a crowd was shouting that its king was Christ! But what was it for the Lord to be the king of Israel? What great thing was it for the King of the Ages to become the king of men?

Therefore, the Son of God is equal to the Father, he is the Word through whom all things were made; the fact that he wanted to be king of Israel is condescension, not advancement. It is an indication of pity, not an increase in power. For he who is called king of the Jews on earth is the Lord of angels in heaven.

<div align="right">Saint Augustine, Commentary on the Gospel of John, Tractate LI, 4</div>

Jesus found a donkey and sat on it, as it was written: "Fear not, daughter of Sion! Behold your king comes sitting on a donkey's colt" (*Zech* 9:9). In that people, therefore, was the daughter of Sion [...] to whom it is said: "Fear not! Behold your king comes sitting on a donkey's colt." This daughter of Sion, to whom these things are divinely said, was among those sheep who heard the voice of the shepherd. She was in that crowd which was praising the Lord with such great devotion as he came and was leading him in so great a column.

The donkey's colt upon which no one had sat (for this fact is found in the other evangelists) we understand to represent the people of other nations who had not received the Lord's law. However the donkey (because both beasts were led to the Lord) is his community which came to be the people of Israel, clearly not unbroken, but which recognised the Master's manger.

Saint Augustine,
Commentary on the Gospel of John,
Tractate LI, 5

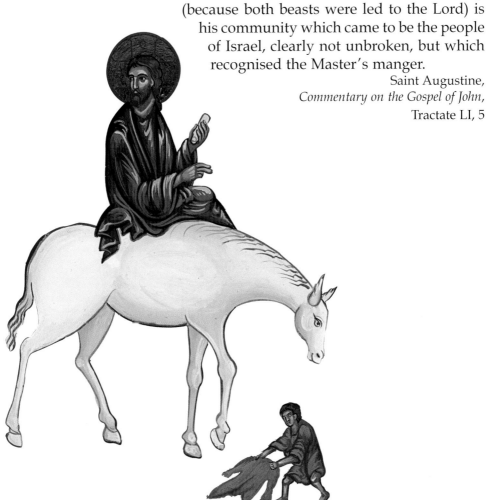

19

The Footwashing
John 13:1-7, 12-15

¹ Now before the festival of the Passover, Jesus knew that his hour had come to depart from this world and go to the Father. Having loved his own who were in the world, he loved them to the end. ² The devil had already put it in the heart of Judas son of Simon Iscariot to betray him. And during the supper ³ Jesus, knowing that the Father had given all things into his hands, and that he had come from God and was going to God, ⁴ got up from the table, took off his outer robe, and tied a towel around himself. ⁵ Then he poured water into a basin and began to wash the disciples' feet and to wipe them with the towel that was tied around him. ⁶ He came to Simon Peter, who said to him, "Lord, are you going to wash my feet?" ⁷ Jesus answered, "You do not know now what I am doing, but later you will understand." […] ¹² After he had washed their feet, had put on his robe, and had returned to the table, he said to them, "Do you know what I have done to you? ¹³ You call me Teacher and Lord—and you are right, for that is what I am. ¹⁴ So if I, your Lord and Teacher, have washed your feet, you also ought to wash one another's feet. ¹⁵ For I have set you an example, that you also should do as I have done to you."

Jesus opens his final evening with his disciples, and the last discourse in the Gospel of John, with words that explain the meaning of his death and resurrection. Through his death and resurrection he will return to the glory with the Father which he had before the world was made (see *John* 17:5), and he will show the immensity of his love for them. It will be a love that manifests itself down to the end of his life, and a love that is the consummation of all human loving. Knowing what lies ahead of him, he nevertheless humbles himself, girding himself only with a towel, as if he were heading for the cross already, and performs the humblest of all services: he washes the feet of his disciples. Little wonder that Peter, not understanding the full significance of what Jesus is doing – sharing with them a symbol of his unconditional love for them – objects. But Jesus insists that unless he is prepared to go through this bathing with water, he cannot have part with him. Only "afterwards," when Jesus has been crucified and raised from the dead will Peter understand that through

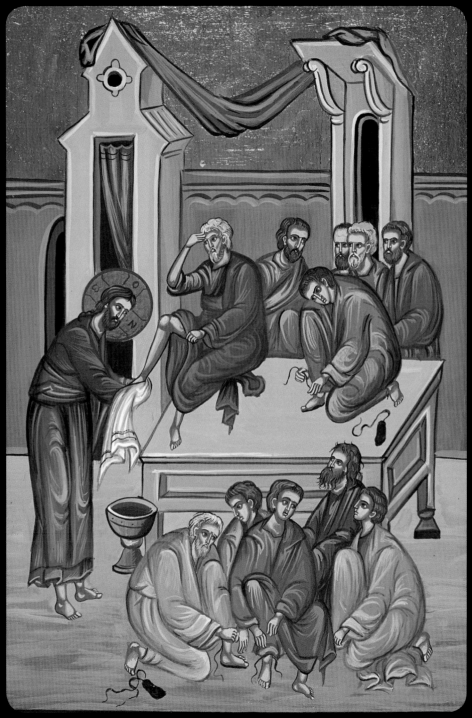

the waters of Baptism we are drawn into the saving effects of Jesus death. Finally, Jesus instructs them, this is something that disciples of Jesus must repeat down through the ages. He has given them an example that they must repeat. As he will say a little later: "I give you a new commandment, that you love one another as I have loved you" (*John* 13:34).

Crucial to the icon are the figures of Jesus and Peter. There is a resistance and yet an acceptance in Peter's gestures. His hand is on his forehead and he wonders what all this might mean. The gaze of Jesus, however, is directed toward all the disciples as they remove their sandals, preparing themselves to be washed by Jesus. But will they be prepared to follow Jesus' new example: "That you also should do as I have done to you"?

Francis J. Moloney, SDB

O Christ, wash my feet. "Forgive us our sins," because our love has not been extinguished, because "we also forgive those who sin against us." When we listen to you, our fragile beings rejoice exceedingly with you in the heavens. But when we preach you, we walk with our feet on the earth so that we might open the way to you. But if we are blamed we become troubled, yet if we are praised we are filled with self-pride. Wash our feet, which once were clean, but have now become soiled as we walk the earth as we come to open the way to you.

Saint Augustine,
Commentary on the Gospel of John, Tractate LVII, 6

The holy disciples, therefore, needed a modest and humble way of life, with no ambition for empty honour. They had many occasions to give in to the sin of pride. They would have easily given way to it, if they had not received great help from the Lord.

96

In fact, the cruel beast of pride always directs its attacks against those who occupy prestigious positions. Think then, what position can be more glorious than that of the holy apostles? Or what can attract more attention than their friendship with God? Thus it has come to be a common characteristic of all who occupy positions of importance that they are liable to attacks of pride. It was surely necessary for the holy apostles to find in Christ an example of humility. Thus, having the Lord of all as their model and standard, they themselves might mould their own hearts according to the will of God.

"If I do not wash you, you can have no part with me." The central point of this passage is clear and obvious: Jesus is saying, "If you should choose to refuse this strange and novel lesson of humility, you will have no part nor lot with me." Often our Lord Jesus Christ, taking his cue from small matters, teaches with wide application. Drawing a wide range of lessons from a single event or words spoken on a particular occasion, he introduces into a discussion of the matters at hand a rich abundance of profitable illustrations. We can therefore suppose that he also meant to say that unless through his grace a man washes away from himself the defilement of sin and error, he shall have no share in the life that proceeds from him. He will remain without a taste of the kingdom of heaven. For the uncleansed cannot enter the mansions above. Only they enter who have had their conscience cleansed by love of Christ, and have been sanctified in the Spirit by holy Baptism.

Saint Cyril of Alexandria,
Commentary on John, IX

20

The Last Supper
Matthew 26:20-29

20 When it was evening, he took his place with the twelve; 21 and while they were eating, he said, "Truly I tell you, one of you will betray me." 22 And they became greatly distressed and began to say to him one after another, "Surely not I, Lord?" 23 He answered, "The one who has dipped his hand into the bowl with me will betray me. 24 The Son of Man goes as it is written of him, but woe to that one by whom the Son of Man is betrayed! It would have been better for that one not to have been born." 25 Judas, who betrayed him, said, "Surely not I, Rabbi?" He replied, "You have said so." 26 While they were eating, Jesus took a loaf of bread, and after blessing it he broke it, gave it to the disciples, and said, "Take, eat; this is my body." 27 Then he took a cup, and after giving thanks he gave it to them, saying, "Drink from it, all of you; 28 for this is my blood of the covenant, which is poured out for many for the forgiveness of sins. 29 I tell you, I will never again drink of this fruit of the vine until that day when I drink it new with you in my Father's kingdom."

The Gospel account of the Last Supper insists upon the frailty of one of the disciples. Jesus takes his place at table with the Twelve. He is about to enter that intimate experience of the shared table, as he announces that one of them will betray him. Not only does this disciple share table, but it is "one who has dipped his hand into the bowl with me." Shock grips the disciples, but Jesus indicates to Judas that he is aware of his betrayer. But he loves these disciples, despite the fact that Judas will betray him. Indeed, before long Peter will deny him and all the others will flee in fear (see *Mark* 14:50). He shows his love for them at a meal that he transforms from a Passover celebration that traditionally looked back to the Exodus for its meaning. At this meal, the new covenant is not founded on the Exodus and the experience at Sinai. Jesus looks forward to speak of his broken body and spilt blood: "Take, eat; this is my body." Then he took a cup, and after giving thanks he gave it to them, saying, "Drink from it, all of you; for this is my blood of the covenant, which is poured out for many for the forgiveness of sins." He gives his very life for disciples who do not love him as he loves them. And this self-gift will go on, as we all continue to drink the new wine in the Kingdom

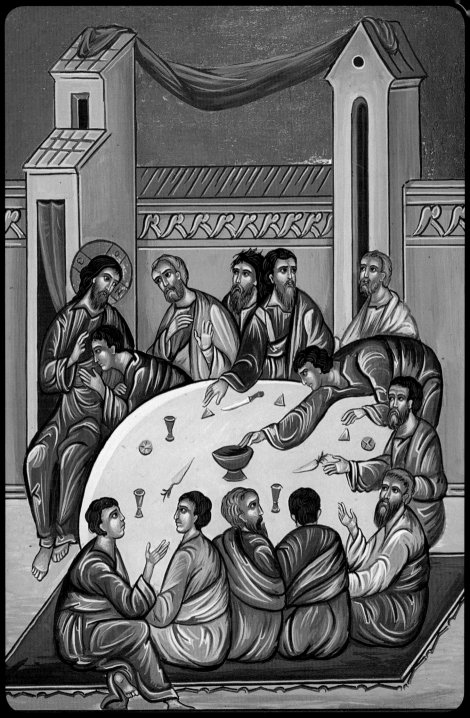

of God. Nowhere in the Christian life is the love of God manifested in the death and resurrection of Jesus more powerfully present than at our Eucharistic celebrations.

The icon catches images from across the Gospels: the Beloved Disciple leans on the breast of Jesus (John), Judas dips his hand into the dish (Matthew and Mark), his hand is upon the table (Luke), and the shocked disciples ask among themselves "Is it I?" (Mathew, Mark and John). But the bread and the cup are also there, even though the icon catches the moment before Jesus' words over them. At this moment there is only the threat of betrayal and the consternation of the disciples. This will be overcome by the new covenant established at the cross "for the forgiveness of sins" (*Matt* 26:28).

<div style="text-align: right">Francis J. Moloney, SDB</div>

What an arrogant person was Judas! He was there and he came to be part of the mystery of this shared table. But at that table he is unmasked. Even an animal would have been more respectful. However, the Evangelist shows that, while they were eating, the Christ spoke of the wickedness of the betrayer within the particular context of a sacred meal. Before the meal he had washed their feet. Notice how respectfully he deals with the betrayer. He did not say, "Such and such will betray me," but "one of you." In this way he gave Judas a final chance to repent, and for his plans of betrayal to remain unknown. Jesus preferred to shock everyone for the sake of saving one of them. One of the Twelve, he says, who has always been with me, whose feet I have just washed, to whom I have promised such blessings. At that moment this sacred group is overcome with an incredible suffering. Matthew says, "And they became greatly distressed and began to say to him one after another,

'Surely not I, Lord?' He answered, "The one who has dipped his hand into the bowl with me will betray me'."

Some say that Judas demonstrated incredible arrogance to disrespect his Master, and to dip his hand into the same dish. To me it appears that the Christ allowed this to happen so that he might be so ashamed of himself that he might be led to think again. This gives the gesture an even greater meaning.

Saint Hilary of Poitiers, *Homilies on the Gospel of Matthew*, LXXXI, 1

We must not pass over these facts superficially, but fix them firmly in our souls. In this way, anger will no longer find a place within us. Pondering this meal, the betrayer who sat at table with the Saviour of all who spoke with such compassion, who would not drive out every trace of the poison of anger? See how carefully Jesus speaks with him.

Reflect again on Jesus' incredible kindness as he makes the accusations. Not even in this case does he express himself in violent tones, but more with compassion and in a veiled manner. If he had not behaved in this way, earlier arrogance may have led to even worse lack of respect and they would have been worthy of even greater indignation. After this accusation, Judas says, "Surely not I, Lord?" What lack of good sense! He interrogates Jesus, all the while aware of the betrayal. Indeed, the Evangelist reports these words amazed by his arrogance. What can one say about the meekness and kindness of Jesus? "You have said so." In this way, he sets for us the limits and the norms for tolerating evil.

Saint Hilary of Poitiers, *Homilies on the Gospel of Matthew*, LXXXI, 2

The Prayer of Jesus in the Garden
Matthew 26:36-46

36 Then Jesus went with them to a place called Gethsemane; and he said to his disciples, "Sit here while I go over there and pray." 37 He took with him Peter and the two sons of Zebedee, and began to be grieved and agitated. 38 Then he said to them, "I am deeply grieved, even to death; remain here, and stay awake with me." 39 And going a little farther, he threw himself on the ground and prayed, "My Father, if it is possible, let this cup pass from me; yet not what I want but what you want." 40 Then he came to the disciples and found them sleeping; and he said to Peter, "So, could you not stay awake with me one hour? 41 Stay awake and pray that you may not come into the time of trial; the spirit indeed is willing, but the flesh is weak." 42 Again he went away for the second time and prayed, "My Father, if this cannot pass unless I drink it, your will be done." 43 Again he came and found them sleeping, for their eyes were heavy. 44 So leaving them again, he went away and prayed for the third time, saying the same words. 45 Then he came to the disciples and said to them, "Are you still sleeping and taking your rest? See, the hour is at hand, and the Son of Man is betrayed into the hands of sinners. 46 Get up, let us be going. See, my betrayer is at hand."

The scene in the Garden of Gethsemane is one of the most important moments in the Gospels for understanding Jesus of Nazareth, Son of Man and Son of God. Aware of the horrific experience that lies ahead of him, as his passion is at hand, he turns to God in prayer. There is an unconditional trust in the God of Israel, whom Jesus calls Father. But he is also in need of human – as well as divine – support. He takes the inner circle of the Twelve with him: Peter, James and John. But they are unable to stay one hour with him. He returns to them, warning them that they must watch and be careful, lest the great temptation overcome them. But they fail in the Garden, as they will fail at Jesus' arrest. They will all run away, and Peter will deny Jesus three times. The temptation is too much for them. Jesus' trust in God, however, never fails. Addressing God as his Father, he accepts whatever the will of his Father asks of him. The scene closes as Jesus finds the disciples asleep for the final time. He warns them that the hour has come, and that they must rise and face what lies

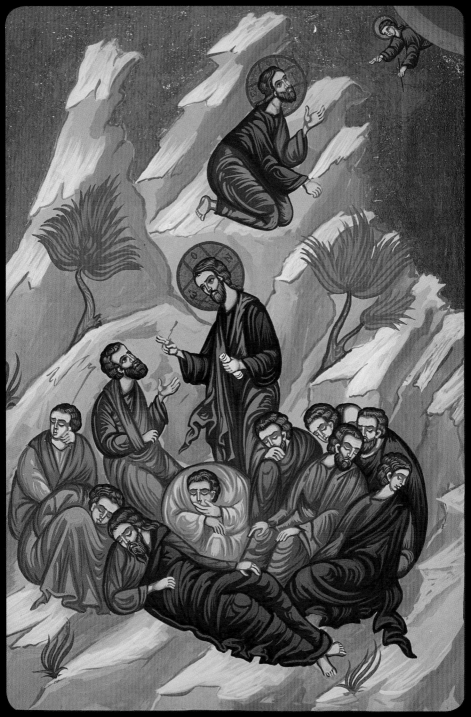

ahead. Jesus will go the way of the suffering Son of Man, prepared to do the will of his Father. The disciples will all succumb to temptation, and fail the man who has loved them so much.

The icon has two levels. At the top Jesus, with hands outstretched, addresses an angel in his prayer that he may be sustained in his final struggle. Below, Jesus speaks to Peter, but his words make no impression on the eleven disciples who are either asleep, or half awake with heavy eyes. They are not prepared for the hour that is at hand.

<div align="right">Francis J. Moloney, SDB</div>

First of all, I appeal to the judgment of our human reasoning about the significance of the expression to be "sad even unto death." To be sad "on account of death" does not mean the same as to be "sad even unto death," for where the sadness is on account of death there the death itself is the cause of the sadness, but where the sadness is unto death there death is no longer the cause, but the end, of the sadness.

<div align="right">Saint Hilary of Poitiers, *The Trinity*, X, 36</div>

Pay attention to how and when he speaks.
He bears all the signs of the human condition and
expresses human emotion. Consequently, you read that going a little farther, he prostrated himself on the ground and prayed, saying, "Father, if it is possible …" He does not speak like God, but like a human being. Can God not know whether something is possible or not? Or perhaps that something is impossible for God, since it is written, "Because with you nothing is impossible" (see *Luke* 1:37)?

<div align="right">Saint Ambrose, *Tractate on the Faith*, II, 5, 42</div>

Christ knew very well what he was saying to the Father, and he knew that it was possible that the chalice be taken from him. But he also knew that he had to drink of it for the sake of all, to wipe away by means of this chalice, the debt that the prophets and the martyrs, even with their deaths, were not able to absolve. Therefore he assumed human flesh and was subject to human frailty. He ate because he was hungry, exhausted himself working, was weakened by sleep. And when the time came for him to die, everything had to take place according to the rules of the flesh, unto death. In this fashion his nature as a son of Adam, where "sin reigned" according to the Apostle (see *Rom* 5:14, 17) was revealed.

Saint Ephrem the Syrian, *Commentary on the Diatessaron of Tatian*, XX, 2.4.6.7

In this fashion Jesus, the good Master and true Saviour, showed compassion for all human beings and their weaknesses. He showed in his own life that the martyrs should not despair even if, in their sufferings, they may have experienced moments of anxiety. This is a consequence of the fragility of the human condition (see *Heb* 2:9, 18; 4:15). They would have no doubt overcome this anxiety if they had been able to place the will of God before their own will. God knows what is useful for all those he cares for.

Saint Augustine, *The Harmony of the Evangelists*, III, 4, 14

The Arrest of Jesus
John 18:1-8, 10-13, 15-17

¹ After Jesus had spoken these words, he went out with his disciples across the Kidron valley to a place where there was a garden, which he and his disciples entered. ² Now Judas, who betrayed him, also knew the place, because Jesus often met there with his disciples. ³ So Judas brought a detachment of soldiers together with police from the chief priests and the Pharisees, and they came there with lanterns and torches and weapons. ⁴ Then Jesus, knowing all that was to happen to him, came forward and asked them, "Whom are you looking for?" ⁵ They answered, "Jesus of Nazareth." Jesus replied, "I am he." Judas, who betrayed him, was standing with them. ⁶ When Jesus said to them, "I am he," they stepped back and fell to the ground. ⁷ Again he asked them, "Whom are you looking for?" And they said, "Jesus of Nazareth." ⁸ Jesus answered, "I told you that I am he. So if you are looking for me, let these men go." […] ¹⁰ Then Simon Peter, who had a sword, drew it, struck the high priest's slave, and cut off his right ear. The slave's name was Malchus. ¹¹ Jesus said to Peter, "Put your sword back into its sheath. Am I not to drink the cup that the Father has given me?" ¹² So the soldiers, their officer, and the Jewish police arrested Jesus and bound him. ¹³ First they took him to Annas, who was the father-in-law of Caiaphas, the high priest that year. […] ¹⁵ Simon Peter and another disciple followed Jesus. Since that disciple was known to the high priest, he went with Jesus into the courtyard of the high priest, ¹⁶ but Peter was standing outside at the gate. So the other disciple, who was known to the high priest, went out, spoke to the woman who guarded the gate, and brought Peter in. ¹⁷ The woman said to Peter, "You are not also one of this man's disciples, are you?" He said, "I am not."

The account of Jesus' arrest in the Gospel of John is strikingly different from that of Matthew, Mark, and Luke. Jesus associated himself closely with his disciples, and goes to a place where another of his disciples, Judas, knows he gathers with them to pray. His enemies come with false lights, lanterns and torches, to lay hands upon him who is the light of the world (see *John* 8:12; 9:5). He renders them powerless as he announces his identity to them: "I am he!" While they are still prostrate, he insists that the disciples go free. They are to be his witnesses and the founders of the Church. But Peter does not understand that God's plan is being

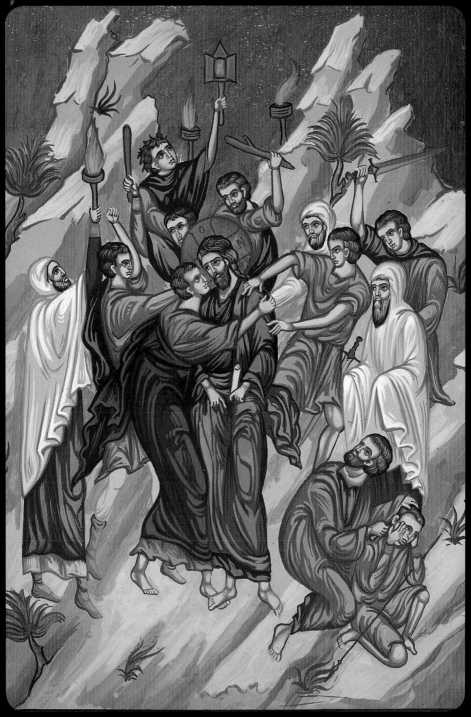

unfolded. He interferes in an understandable human way as he attempts to protect his Master, only to be reproved by Jesus, as he must accept the chalice the Father has given him. After Jesus is arrested, this same Peter is asked whether he is a disciple of Jesus. Jesus affirmed the truth when he proclaimed "I am he!" Peter tells a lie as he says "I am not."

The icon tells the story of the false light, the violence, and the betrayal of Judas. In the foreground we also see the futile act of Peter, cutting off the ear of Malchus. But at the centre of the icon stand Jesus and Judas. The gesture used by Judas was a sign of love, and the icon catches Jesus' love for Judas to the very end. His gaze into the eyes of Judas is not one of fear and anger, and he has his foot resting upon the foot of Judas. He is not in a hurry to separate himself from his lost disciple.

Francis J. Moloney, SDB

The wolf, concealed by a sheep's skin and tolerated among the sheep by the profound plan of the father of the family, learned where, for a short time, he might scatter the flock by insidiously attacking the Shepherd. "Judas, therefore, when he had taken a cohort and servants from the chief men and the Pharisees, came there with lanterns and torches and weapons." The cohort was not of Jews but of soldiers. Therefore, let it be understood that they are there at the order of the governor, as though arresting a criminal. In this way, since the order of lawful authority was observed, no one might dare to resist those making the arrest, even though the band had been gathered in so great a number and was coming armed to such an extent that it would

either terrify, or even fight back, if anyone should dare to defend Christ. Indeed his power was so hidden and his weakness so veiled that these actions seemed necessary to his enemies against him. For Jesus, however, nothing would take place except what he himself wished to happen. Jesus used evil to good effect, and brought out good from evil to make good men out of the evil and to distinguish the good from the evil.

Saint Augustine, *Commentary on the Gospel of John*, CXII, 2

Where now are the cohort of soldiers and the servants of the chief men and the Pharisees? Where are the terror and protection of weapons? His lone voice said, "I am he." Without any weapon he smote, repulsed and struck down a crowd, fierce in its hatred and frightfully armed! For God was hidden in the flesh. The light of the world was so concealed by the human person of Jesus that, to be slain by the darkness, he was sought after with lanterns and torches.

Saint Augustine, *Commentary on the Gospel of John*, CXII, 3

They grasped him to whom they did not draw near; for he was the light of the world. They continued to be darkness and did not hear the invitation: "Draw near to him and be enlightened." If they drew near, they would grasp him not to kill him with their hands but to receive him into their hearts. But at this moment when they grasped him violently, they drew farther back from him; and they bound him by whom rather they ought to have wished to be loosed. Perhaps among them there were some who put their bonds upon Christ but were afterwards set free by him. They then said: "You have broken my bonds".

Saint Augustine,
Commentary on the Gospel of John, CXII, 6

The Scourging of Jesus at the Pillar
Matthew 27:27-31

> [27] Then the soldiers of the governor took Jesus into the governor's headquarters, and they gathered the whole cohort around him. [28] They stripped him and put a scarlet robe on him, [29] and after twisting some thorns into a crown, they put it on his head. They put a reed in his right hand and knelt before him and mocked him, saying, "Hail, King of the Jews!" [30] They spat on him, and took the reed and struck him on the head. [31] After mocking him, they stripped him of the robe and put his own clothes on him. Then they led him away to crucify him.

When the Gospels tell of Jesus' suffering and death, the story is always told at two levels. On the one hand, there is the reporting of the incredibly cruel sufferings that were imposed upon him by an illegitimate authority. These sufferings are rendered even more excruciating by the fact that Jesus was an innocent person. The mockery of Jesus reported in the Gospel of Matthew tells this story: the whole cohort gathers, they dress him as a king in mockery, spit upon him and strike him on the head with the reed they had placed in his hand in imitation of a royal sceptre. Notice, however, that Matthew (like Mark and Luke) does not report a scourging (only found in *John* 19:1). Matthew's main interest is the profound truth that is being told in the soldiers' actions: they mockingly dress him as a king and prostrate themselves before the king. They then proclaim the truth: "Hail, King of the Jews." They are telling the truth, even though they are not aware of it. As we read this passage we are aware that Jesus was not a king in a way most would expect. As Jesus says in the Gospel of John: "My kingship is not of this world" (*John* 19:36). Jesus is king in his loving gift of himself to the will of the Father, through suffering, to bring hope and salvation to the whole world.

The icon does not focus upon the Gospel message of Jesus' kingship, except in one detail. The setting of the inside of the praetorium, the fierce flogging of the soldiers and Jesus' being hung upon the pillar present the suffering of the innocent Jesus. But his eyes are cast upward. There

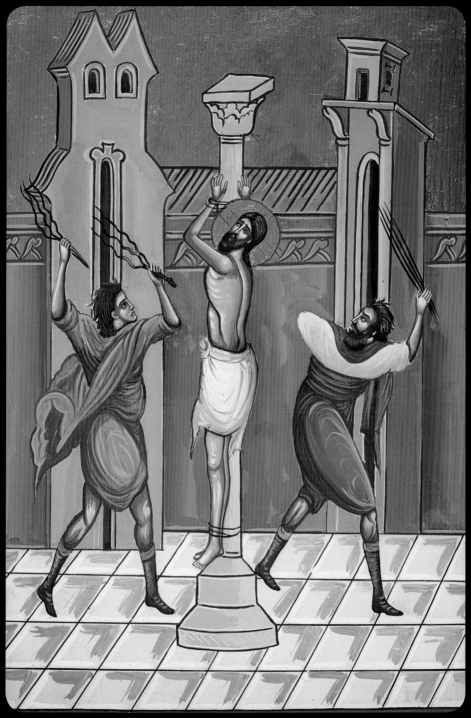

is no indication of his suffering, just a gaze towards the Father. Finally, he is already crowned with the halo of the sanctity and royalty that his death and resurrection announce to all believers.

Francis J. Moloney, SDB

Pilate has Christ scourged unjustly, and he lets the crowd of soldiers insult him, put a crown of thorns on his head, throw a purple robe upon him, and buffet him with the palms of their hands and dishonour him with insults. For Pilate believed he could easily put to shame the Jewish people if they saw the man who was utterly free of guilt suffering this unreasonable torment. He was scourged unjustly, that he might deliver us from merited chastisement. He was buffeted and smitten, that we might buffet Satan who has buffeted us, and that we might escape from the sin that cleaves to us as a result of the original transgression.

Saint Cyril of Alexandria,
Commentary on the Gospel of John, XII

In what way are "we healed by his stripes," according to Scripture? Because "we had all gone astray, every man after his own way," says the prophet Isaiah. The Lord God has given Jesus up for our transgressions, and for us he is afflicted. For he was bruised for our iniquities, and has given his own back to those who scourge, and his cheeks to those who smite, as the prophet also says (see *Isaiah* 53:3-6).

Saint Cyril of Alexandria,
Commentary on the Gospel of John, XII

Pilate confesses the wrong he has done, and is not ashamed. For he admits that he had him scourged without a cause, and declares that he will show him to them, supposing that he would satisfy their savage passion by so pitiable a spectacle. He almost accuses them publicly of putting Jesus to death unjustly, by compelling him openly to be a lawbreaker. If Pilate transgressed his own laws, he could not escape scot free. The saying was fulfilled in Christ and shown to be true that, "the prince of this world comes, and he will find nothing against me." Observe how Satan, after throwing everything into confusion, finds no crime in God. There is no sin, therefore, that Christ the Saviour could be justly accused of. The whole of humankind was subjected to sin in Adam, but Jesus is victorious over sin.

Saint Cyril of Alexandria,
Commentary on the Gospel of John, XII

Simon of Cyrene Carries the Cross of Jesus
Luke 23:26-32

²⁶ As they led him away, they seized a man, Simon of Cyrene, who was coming from the country, and they laid the cross on him, and made him carry it behind Jesus. ²⁷ A great number of the people followed him, and among them were women who were beating their breasts and wailing for him. ²⁸ But Jesus turned to them and said, "Daughters of Jerusalem, do not weep for me, but weep for yourselves and for your children. ²⁹ For the days are surely coming when they will say, 'Blessed are the barren, and the wombs that never bore, and the breasts that never nursed.'"³⁰ Then they will begin to say to the mountains, 'Fall on us'; and to the hills, 'Cover us.' ³¹ For if they do this when the wood is green, what will happen when it is dry?" ³² Two others also, who were criminals, were led away to be put to death with him.

On his way to the place of the skull, Simon of Cyrene is forced to carry the cross of Jesus. They "laid on him the cross, to carry it behind Jesus." The passion of Jesus sets the pattern for discipleship, as Simon is a model of future Christians who will be called to follow Jesus on this final journey. He is also followed by many people, including women of Jerusalem who weep and lament over him. Whatever may have been the cause for the decision of the multitude to ask for Jesus' death, there are still many who support Jesus and are in sorrow as he goes to death. There is never total opposition to Jesus. Jesus speaks to them, continuing his role as a prophet. As he drew near to Jerusalem he wept (*Luke* 19:42-43). In the Temple he foretold the future destruction of the city and its Temple (*Luke* 21:20-23). The women are both warned and challenged by the words of Jesus. If this is happening to me now, as I am slain by the Romans, how much more savage will be the experience of those who are guilty of his death? Readers of this Gospel, more than a decade after the destruction of the city (70 AD) sense the poignancy of Jesus' telling the women that they will ask the mountains to fall on them and the hills to cover them. As Jesus entered the city, he wept over it as he prophesied its destruction. As he leaves it, to be crucified outside

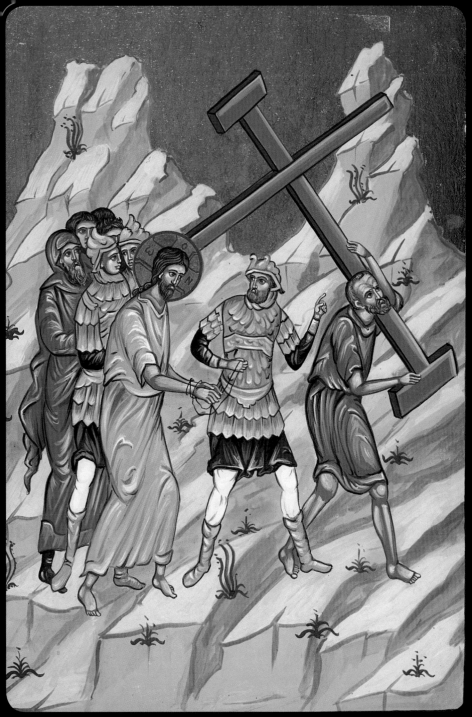

the city walls, inhabitants of Jerusalem weep over him, and he again prophesies the destruction of the city.

In the icon the figure of the centurion stands between Jesus, who is bound to him and the cross being carried by Simon. The centurian stands where the upright and the two arms of the cross intersect. He points to the cross. Unlike the Gospel story, Simon does not follow Jesus, but leads. Nevertheless, the two men are linked by means of the cross itself across the centurion. The cross of Jesus is carried by Simon, as it has been carried by myriads of Christians since that day.

Francis J. Moloney, SDB

But let him, already victorious, raise his trophy. For the cross is placed on his shoulders as a trophy. Whether Simon or Jesus bore it – it is always the Christ who bore it in the mutual abiding of the Christ and the human being. The accounts of the evangelists do not disagree. The mystery agrees that for our benefit an order of events had to take place. He himself first raised the trophy of his cross, and then handed it over to the martyrs so that they might raise it on high. Simon who bears the cross is not Jewish, but a stranger and foreigner. He does not go before, but follows; as it is written: "take up your cross and follow me" (*Luke* 9:23). For Christ ascended not his cross but ours. Nor was that the death of the Godhead but, as it were, in the image of the death of a human being. For Jesus himself cried out: "O God, my God, why have you forsaken me" (*Matt* 27:46; see *Psalm* 21:1).

Saint Ambrose,
Commentary on the Gospel According to Luke, X, 107

Now, since we have already seen the sign of victory, let the conqueror mount his chariot. He hangs not on the branches of a tree, nor is he carried away as booty in the chariots of a mortal enemy. He gathers all that remains of the prisoners who have been torn from this world on his triumphant cross. Here, we do not see nations with their hands bound behind their backs, nor images of destroyed cities, nor portraits of captured towns, or marvel at the bent heads of captive kings, as is customary in the portrayal of human triumphs. We see no victories circumscribed by the boundaries of a region. On the contrary, we see the rejoicing peoples of all the nations. They were not conquered for punishment, but for reward, for kings adoring with free minds, for cities that have given themselves over to voluntary humble recognition, and images of cities reshaped for the better. The image is not created to trick, but to portray the devotion of faith. We see the trappings of victory disappear and the spirits of evil who dwell in the heavenly parts become obedient to the voice of a man. The Dominations and the Powers submit themselves, not adorned with silk clothing, but with goodness. Chastity, faith and generous devotion shine forth. The unique triumph of God, the cross of the Lord, has now made it possible, one could say, that all humankind is in triumph.

Saint Ambrose,
Commentary on the Gospel According to Luke, X, 109

The Death of Jesus on the Cross
Luke 22:33-38, 44-47

> [33] When they came to the place that is called The Skull, they crucified Jesus there with the criminals, one on his right and one on his left. [34] Then Jesus said, "Father, forgive them; for they do not know what they are doing." And they cast lots to divide his clothing. [35] And the people stood by, watching; but the leaders scoffed at him, saying, "He saved others; let him save himself if he is the Messiah of God, his chosen one!" [36] The soldiers also mocked him, coming up and offering him sour wine, [37] and saying, "If you are the King of the Jews, save yourself!" [38] There was also an inscription over him, "This is the King of the Jews." […] [44] It was now about noon, and darkness came over the whole land until three in the afternoon, [45] while the sun's light failed; and the curtain of the temple was torn in two. [46] Then Jesus, crying with a loud voice, said, "Father, into your hands I commend my spirit." Having said this, he breathed his last. [47] When the centurion saw what had taken place, he praised God and said, "Certainly this man was innocent." [48] And when all the crowds who had gathered there for this spectacle saw what had taken place, they returned home, beating their breasts.

Jesus is led to the place of the skull and is crucified between two criminals. Jesus is innocent, and not a criminal, but his concern on the cross is to offer salvation to those who are sinners. His first words from the cross offer pardon and forgiveness to those who have crucified him: "Father, forgive them, for they know not what they do." The responses from the rulers and the soldiers take up truths proclaimed earlier in the Gospel: "If he is the Christ of God, his Chosen one, King of the Jews." The rulers scoff, "He saved others, let him save himself" and the soldiers mock, "save yourself." Jesus' earlier prophecy is acted out: "Doubtless you will quote me this proverb, 'Physician heal yourself'" (*Luke* 4:23). Jesus, the innocent crucified one, is Christ of God, Chosen one, King of the Jews, Saviour, and Prophet. The central Christological message of the Gospel of Luke is proclaimed at the cross. Signs that indicate the end of an era and the tearing open of the veil of the Temple, indicating the end of God's former ways with Israel, greet the death of Jesus. With the turning point of the ages achieved, and the Holy of Holies open to the rest of the world,

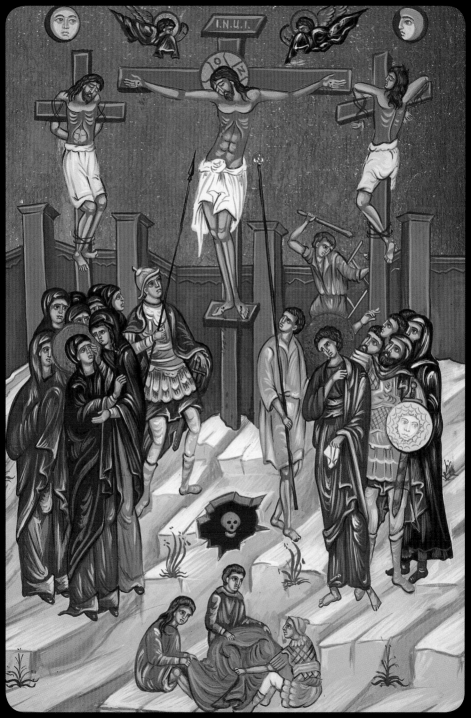

Jesus dies. He cries out, triumphantly: "Father, into your hands I commend my spirit." The Gentile centurion proclaims: "Certainly this man was innocent." Luke, who has never condemned the ordinary people, reports: "And all the multitudes who assembled to see the sight, when they saw what had taken place, returned home beating their breasts." Repentance begins immediately, as Jesus' death saves.

The icon captures many of the images that belong to the Gospel of John, rather than the Lukan story that we have read: the pierced side, the broken legs of the thieves, the presence of the Mother of Jesus and the Beloved Disciple and the soldiers' discussion over Jesus' seamless garment. But the skull appearing at the foot of the cross proclaims the truth found in all the Gospels: Jesus' death overcomes sin and death.

Francis J. Moloney, SDB

It is important to consider what manner of man mounts the chariot of his triumph. I see him naked. Let him who prepares to conquer this generation so ascend that he does not seek the help of the world. Adam who desired clothing was conquered. He who laid down his garments conquered. He ascended his throne in the same way as the design of God the creator has shaped our nature. As the first Adam dwelt in Paradise, so also the second Adam entered Paradise. And because he was not victorious only for himself but also for us, he stretched out his hands to draw all things to himself. Having set everything free from the bonds of death by attaching them to the yoke of faith, he associated it with heavenly realities.

Saint Ambrose,
Commentary on the Gospel According to Luke, X,110

This is no ordinary superscription. The cross was placed at the centre so that all could see it; perhaps above the grave of Adam, as the Hebrews contend. Indeed, it was fitting that the first fruits of our life were placed where death had its beginnings.

Saint Ambrose,
Commentary on the Gospel According to Luke, X, 114

The garments of Christ were divided – his deeds and his graciousness – but his inner tunic could not be divided. The tunic represents the faith, and it cannot be divided because it is not given as something that is accepted by each person singly, but it is the property of all, without distinction. That which is not divided among the many, remains in its entirety.

Fittingly the inner tunic was "woven from top to bottom," because faith in Christ is so woven that it descends from the divine to the human, in so far as he, born of God before the ages, in due time became flesh. Consequently, this teaches us that the faith must not be torn apart, but must be maintained in its entirety.

Saint Ambrose,
Commentary on the Gospel According to Luke, X, 119-120

Mary, in a fashion that was fitting for the Mother of Christ, stood before the cross when the apostles fled. She gazed with pious understanding upon the wounds of her Son, because she expected not the death of a criminal, but the salvation of the world. Or perhaps, because she recognised that the redemption of the world depended upon the death of her son. Mary, "the royal dwelling place," thought that she would add to Jesus' universal gift by her own death. But Jesus did not need a helper in the redemption of all. He accepted the compassion of his mother, but did not seek the help of another human being.

Saint Ambrose, *Commentary on the Gospel According to Luke*, X, 132

The Burial of Jesus
Luke 23:50-56

⁵⁰ Now there was a good and righteous man named Joseph, who, though a member of the council, ⁵¹ had not agreed to their plan and action. He came from the Jewish town of Arimathea, and he was waiting expectantly for the kingdom of God. ⁵² This man went to Pilate and asked for the body of Jesus. ⁵³ Then he took it down, wrapped it in a linen cloth, and laid it in a rock-hewn tomb where no one had ever been laid. ⁵⁴ It was the day of Preparation, and the Sabbath was beginning. ⁵⁵ The women who had come with him from Galilee followed, and they saw the tomb and how his body was laid. ⁵⁶ Then they returned, and prepared spices and ointments. On the Sabbath they rested according to the commandment.

An unknown leader of the people, Joseph from the Judean town of Arimathea who had not consented to all that had been done, emerges and buries Jesus in a new tomb. The Evangelist Luke shows that there were many in Israel who were not party to the slaying of Jesus. People who had come from Galilee were present at the cross, and a man from Judea sees to his burial. Not only is he a man from Judea, but he is also a member of the council, who had not agreed to their plans and actions. Jesus is "King of all the Jews," despite the leadership that has executed the innocent Messiah. It is the day of the Preparation, the eve of the Sabbath. Watched by women, Jesus is taken down and buried. The women know how and where he is buried, and return to the city to prepare the spices and ointments. "On the Sabbath they rested according to the commandment." The rapid succession of a series of violent events that mark the passion story slows down. Indeed, it comes to a stop, as the women rest and wait. The Christian reader, who knows that this is not the end of Jesus' story, also waits.

Characters from across the Gospel stories of Jesus' burial appear in the icon. The Beloved Disciple gazes at the body of the man he has loved, and touches him tenderly. The Mother of Jesus, also present at the Cross with the Beloved Disciple in the Gospel of John (see *John* 19:25-27), cradles

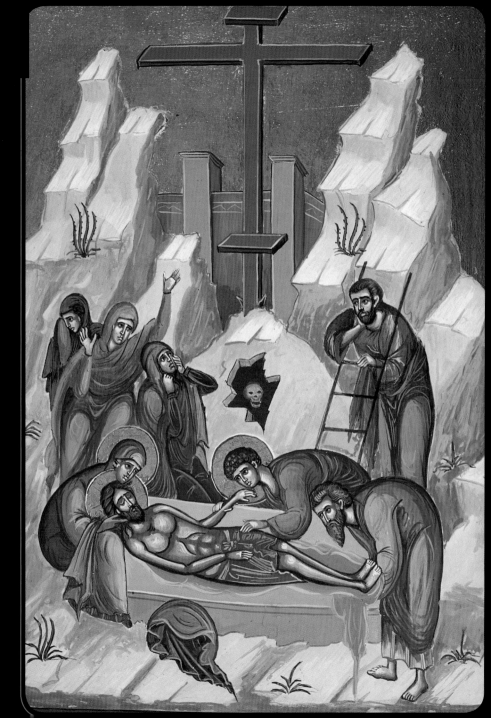

the head of her son on her lap. Nicodemus and Joseph of Arimathea, both leaders of the Jews, prepare for the burial: Nicodemus wraps Jesus in the linen cloth and Joseph stands by with the ladder ready to place Jesus in the tomb. Dominating the central background of the icon is an empty cross: the promise of a resurrection that overcomes the death on the cross.

Francis J. Moloney, SDB

What does it matter that Joseph and Nicodemus, not the apostles, bury Christ. Joseph is good and righteous (see *John* 19:38-39), Nicodemus is a man in whom there is no guile (see *John* 1:47). In the burial of Jesus there is no place for deceit or subterfuge. Any possibility that Jesus may escape is rendered impossible, and the claims of the Jewish leaders can be refuted by the evidence of one of their own. If the apostles had buried him, they would surely have said that Jesus was not buried, but had been stolen away (see *Matt* 28:13).

Saint Ambrose, *Commentary on the Gospel According to Luke*, X, 136

A righteous man wrapped Christ's body in fine linen and a guileless man anointed him with ointment. This distinction is not made idly, because righteousness clothes the Church and innocence administers grace. Therefore, clothe the body of the Lord with his glory so that you too may be righteous. Even though you believe the body to be dead, cover it with the fullness of its divinity (see *Col* 2:9). Anoint it with myrrh and aloe that you may be the sweet fragrance of Christ.

Saint Ambrose, *Commentary on the Gospel According to Luke*, X, 137

Luke said that this Joseph was righteous (*Luke* 23:50), Matthew that he was rich (*Matt* 27:57). Rightly is he here said to be rich as he received the body of Christ. By receiving the riches of faith, he did not know poverty. Therefore, whoever is righteous is rich. Then he wrapped it in fine linen, and the Israelite (Nicodemus, see *John* 1:47) mixed different fragrances of virtues and added a hundred pounds of aloes (see *John* 19:39-40), symbolically, the amount of perfect faith. And they bound the body according to the custom and the true spirit of Judaism (see *John* 19:40), not with knots of treachery, but with bands of faith. They laid it in a garden, to which the Church is often compared, which has fruits of different merits and flowers of virtue.

Saint Ambrose, *Commentary on the Gospel According to Luke*, X, 139

If death is common to all human beings, the death of Christ is unique. He is not buried with others, but laid alone in a grave. Indeed, the incarnation of the Lord was human in all ways, but there is a likeness with a difference of nature. There is a likeness of birth from a virgin and a difference in his conception. He cured the sick, but commanded them. John baptised with water, he with the Spirit. And, therefore, the death of Christ is like the death of all humankind in its bodily aspect, but unique in its power.

<div align="right">Saint Ambrose, Commentary on the Gospel According to Luke, X, 140</div>

The simple burial of the Lord condemns the ambition of the rich, who even in their burials have to display their wealth ... From this event comes the liturgical practice of the Church in the sacrifice of the altar. It is not celebrated on a silk drape, or even a painted cloth. It is celebrated on a sheet of natural linen, as the body of the Lord was wrapped in a white cloth.

<div align="right">Bede the Venerable, Commentary on the Gospel of Mark, IV, 15, 46.</div>

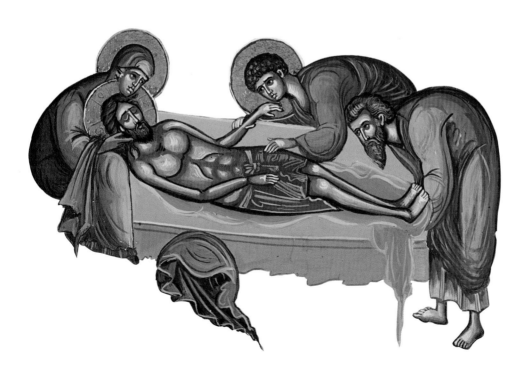

The Women at the Tomb
Mark 16:1-11

¹ When the sabbath was over, Mary Magdalene, and Mary the mother of James, and Salome bought spices, so that they might go and anoint him. ² And very early on the first day of the week, when the sun had risen, they went to the tomb. ³ They had been saying to one another, "Who will roll away the stone for us from the entrance to the tomb?" ⁴ When they looked up, they saw that the stone, which was very large, had already been rolled back. ⁵ As they entered the tomb, they saw a young man, dressed in a white robe, sitting on the right side; and they were alarmed. ⁶ But he said to them, "Do not be alarmed; you are looking for Jesus of Nazareth, who was crucified. He has been raised; he is not here. Look, there is the place they laid him. ⁷ But go, tell his disciples and Peter that he is going ahead of you to Galilee; there you will see him, just as he told you." ⁸ So they went out and fled from the tomb, for terror and amazement had seized them; and they said nothing to anyone, for they were afraid. ⁹ Now after he rose early on the first day of the week, he appeared first to Mary Magdalene, from whom he had cast out seven demons. ¹⁰ She went out and told those who had been with him, while they were mourning and weeping. ¹¹ But when they heard that he was alive and had been seen by her, they would not believe it.

The Sabbath has now passed, and the women who were at the cross and at the tomb bring spices to anoint Jesus' body. Light is dawning on this "first day of the week" as they approach the tomb, asking who will roll away the stone. The glow in the icon catches the early light. The stone was very large, but it had already been rolled back. As the women enter the tomb, they see a young man sitting on the right side, dressed in a white robe. He is shown in the icon, seated at the right, on a large rock that has been rolled away. The words of the young man tell them they are looking in the wrong place. They are seeking Jesus, the Nazarene, the crucified. They are told to look at the place where the dead body had been laid. He is not there, because he has been raised! God has entered the story. Jesus' question from the cross, "My God, my God, why have you forsaken me" (*Mark* 15:34) has been answered. God has not forsaken Jesus. The women are told to announce the Easter message: "go, tell his

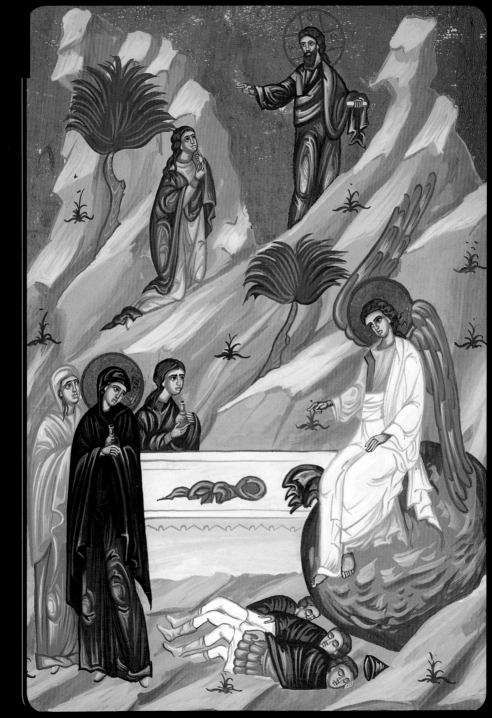

disciples and Peter that he is going before you to Galilee; there you will see him, as he told you." The angel in the icon instructs them firmly, with his hand pointing them away from the tomb. They say nothing to anyone, for they were afraid, and thus the original Gospel of Mark came to a close. But in the second century further verses were added to this ending, and we have some of them here. Mary Magdalene overcomes the fear of the rest of the women and announces the Easter message, but no one believes. The upper section of the icon records Jesus' instruction of Mary Magdalene to go and tell the disciples (see *John* 20:17). In this way the Evangelists make it clear that Easter faith is not born until the risen Jesus enters the life of the believer and they can confess: "The Lord has truly risen" (*Luke* 24:35).

Francis J. Moloney, SDB

Speaking mystically, the evangelist was striving to suggest the great dignity this most sacred night acquired from the glory of our Lord's victory over death. He mentioned that when the women devoted to Christ began to look to performing their service toward him, the following dawn had begun to break. Our Lord, the author and controller of time, he who rose from the dead during the final part of the night, surely caused the whole of it to be festal and bright by the light of his resurrection.

Bede the Venerable, *Homilies on the Gospels*, II, 7

Our Lord and Redeemer revealed the glory of his resurrection to his disciples gradually and over a period of time, no doubt because the virtue of the miracle was so great that the weak hearts of mortals could not grasp the significance of this all at once. Thus he had regard for the frailty of those seeking him. To those who came first to the tomb, both to the women who were aflame with love for him and to the disciples, he showed the stone rolled back. And

since his body had been carried away, he showed them the linen cloths in which it had been wrapped, lying there empty. Then, to the women who were searching eagerly, and who were confused in their minds as to what they had found out about him, he showed a vision of angels who were to disclose by certain evidence that he had truly risen. Thus, with the Easter proclamation already made, the Lord of Hosts and the King of Glory finally appeared to them and made it clear with what great might he had overcome the death he had temporarily tasted.

Bede the Venerable, *Homilies on the Gospels*, II, 9

We also need to be well aware of the meaning of the angel seated to the right of the tomb. Is the left hand side not a symbol of our present life and the right a symbol of eternal life? As our Redeemer had already overcome the corruption of our present form of life, it is only right that the angel who came to announce eternal life was seated on the right. He was dressed in a white garment, a symbol of the rejoicing that marks our celebration, as white sets off the brilliance of this event.

Saint Gregory the Great,
The 40 Homilies on the Gospels, II, 21, 2

The Apparition of the Risen Jesus to Thomas
John 20:24-29

> [24] But Thomas (who was called the Twin), one of the twelve, was not with them when Jesus came. [25] So the other disciples told him, "We have seen the Lord." But he said to them, "Unless I see the mark of the nails in his hands, and put my finger in the mark of the nails and my hand in his side, I will not believe." [26] A week later his disciples were again in the house, and Thomas was with them. Although the doors were shut, Jesus came and stood among them and said, "Peace be with you." [27] Then he said to Thomas, "Put your finger here and see my hands. Reach out your hand and put it in my side. Do not doubt but believe." [28] Thomas answered him, "My Lord and my God!" [29] Jesus said to him, "Have you believed because you have seen me? Blessed are those who have not seen and yet have come to believe."

The Gospel of John, like all the Gospels, shows hesitation among the disciples when faced with the truth that Jesus has been raised from the dead. When Jesus first appeared to the disciples in the upper room Thomas was not there. When he is told that Jesus is risen, he imposes his conditions. He will not believe "unless" he sees Jesus' pierced hands and side. Only when Jesus confronts him, and asks if he wishes to test the signs of his suffering and death does Thomas adopt the position of a believer. He abandons his doubt, and he believes in Jesus as his Lord and his God. But Jesus looks beyond the unique experience of the disciple Thomas who had the privilege of actually seeing and perhaps touching the risen Christ. He believed because of what he saw. He blesses all of those – including ourselves – who, over the Christian centuries, have believed without seeing.

The beautifully balanced icon gathers the eleven disciples around Jesus in three evenly spaced panels. Hands from both sides point to the central figure of the risen Jesus whom the first disciples were able to see. Thomas leans forward with his finger stretched out to touch the wounds of Jesus so that his conditions for belief might be fulfilled. But Jesus' hand

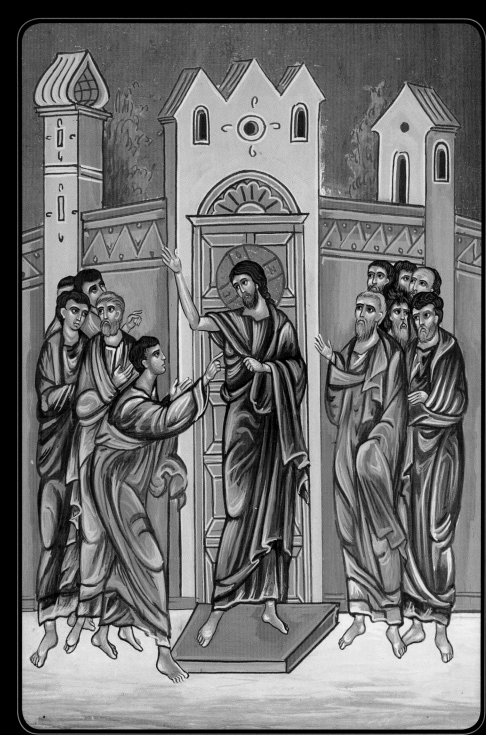

and arm are raised in blessing. Jesus looks beyond the privileged eleven to the millions who "have believed without seeing." They are blessed!

<div align="right">Francis J. Moloney, SDB</div>

The greatest marvels are always greeted with incredulity, and any action which seems to exceed the measure of probability is not well received by those who hear it. But seeing succeeds in eliminating these doubts. It compels a person to assent to the evidence that can be seen. This was the state of mind of the wise Thomas, who did not readily accept the other disciples' testimony to our Saviour's resurrection, although according to the Mosaic Law, every word of two or three witnesses had to be accepted.

I believe that the disciple's lack of faith was extremely opportune and well-timed. This is the case because, through the eventual satisfaction of Thomas' mind, we who come after him might be unshaken in our faith: the body that hung upon the cross and suffered death was quickened by the Father through the Son. Notice that Thomas does not simply desire to see the Lord, but looks for the marks of the nails, the wounds upon his body. For he claimed that at that sight he would believe and agree with the other disciples that Christ had indeed risen, risen in the flesh. That which was dead may rightly be said to have returned to life. A true resurrection only takes place with a person who was really dead.

The writer of this book took pains to observe not only that Christ manifested himself to the disciples, but explains that it was after eight days, and that they were gathered together. What else can their being all brought together in one house mean? We say this to point out the diligent care that the apostle so admirably displays, and because Christ hereby has made clear to us the importance of our assembling, and gathering ourselves together on his account, on the eighth day. For he visits, and mysteriously dwells with those assembled together for his sake, especially on the eighth day, that is, the Day of the Lord.

With good reason, then, we are accustomed to have sacred meetings in Churches on the eighth day. And, to adopt the language of allegory, as the idea necessarily demands, we close the doors. Nevertheless, Christ visits us and appears to us all, both invisibly and also visibly; invisibly as God, but also visibly in the Eucharistic body. He permits us to touch his holy flesh, and shares himself with us. For through the grace of God we are admitted to partake of the Blessed Eucharist, receiving Christ into our hands, to the intent that we may firmly believe that he did in truth raise up the temple of his body. The partaking of the Blessed Eucharist is a confession of the resurrection of Christ. This is clearly shown by his own words, spoken when he performed the type of the mystery. He broke bread, as it is written, and gave it to them saying: "This is my body, which is given for you for the remission of sins: do this in remembrance of me."

<div style="text-align: right;">

Saint Cyril of Alexandria,
Commentary on the Gospel According to John, XII

</div>

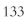

The Blessing of the Disciples
Matthew 28:16-20

> [16] Now the eleven disciples went to Galilee, to the mountain to which Jesus had directed them. [17] When they saw him, they worshiped him; but some doubted. [18] And Jesus came and said to them, "All authority in heaven and on earth has been given to me. [19] Go therefore and make disciples of all nations, baptising them in the name of the Father and of the Son and of the Holy Spirit, [20] and teaching them to obey everything that I have commanded you. And remember, I am with you always, to the end of the age."

This passage famously concludes the Gospel of Matthew. It is an ending that opens to the future. The disciples gather at "the mountain," a scene that recalls his famous sermon on the mountain (*Matt* 5-7). Many of them believe, but there are still some who doubt. Even the sight of the risen Jesus is not enough to bring all disciples to unconditional faith in Jesus. He tells them that God has now given him all the authority that properly belongs to God: in heaven and on earth. On the basis of that authority, Jesus sends out the disciples to teach and to proclaim the Gospel to all nations. The world of the Old Israel is being expanded. Jesus is now Lord, and he sends his disciples out to the whole world, not just to one nation. He instructs them to abandon the initiation rite of circumcision and begin a new rite: baptism in the name of the Father, the Son and the Holy Spirit. No longer are they to teach the Laws taught by Moses. They are to teach everything that Jesus has taught them. Thus the great commission in the Gospel of Matthew is not an ending but a beginning that invites us all into a discipleship that believes in the risen Lord, with us till the end of the age, and that participates in the evangelisation of the nations.

Have you noticed the craggy mountain that is regularly found in the background of so many of the icons of Tbilisi (see icons 4, 5, 7, 9, 10, 12, 13, 16, 18, 21, 22, 24, 25, 26, 27)? It will reappear in the final icon of the Ascension. The mountain has been used by the iconographer to link the whole of the life of Jesus around one theme. The Mountain where

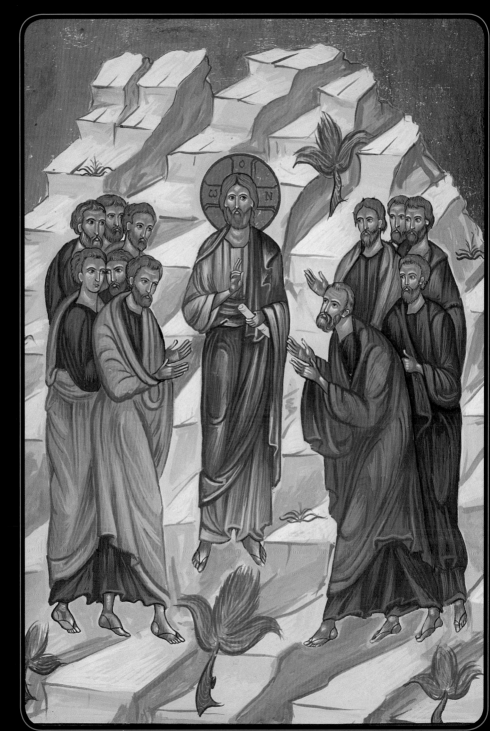

the God of Israel showed his face to Moses is the place where Jesus shows his face to us through the icons. Jesus fulfils the promise made by God to Moses, that he would speak to him "face to face" (see *Deut* 34:10; *Ex* 33:11). The Mountain is also the place where Jesus encourages us with his final words to the disciples: "I am with you always, to the end of the age."

Francis J. Moloney, SDB

It is finally clear and a delight for God's people to hear that "the disciples went into Galilee, to the mountain where Jesus had directed them, and upon seeing him, they adored him." Somewhat mysteriously, after his resurrection our Lord appeared to his disciples on a mountain, in Galilee. This was to make known that the body which at his birth he had assumed from the earth common to the rest of the human race was now, at his resurrection, clothed with heavenly power. His body has been raised above everything earthly. He appeared on a mountain to advise his faithful ones that if they wished to see the loftiness of his resurrection in heaven, they should overcome their earthly cravings to attain their heavenly desires.

"All power in heaven and on earth has been given to me." He was not speaking here about the divinity co-eternal with the Father but about the humanity he had assumed. By putting it on he was made a little lower than the angels; by rising in it from the dead he was crowned with glory and honour, and set over the works of his Father's hands, with all things brought to subjection under his feet. Among all the things brought to subjection under his feet was death itself, which seemed to prevail over him for a time, but which was placed under his feet, subservient.

"Go and teach all nations, baptising them in the name of the Father and of the Son and of the Holy Spirit, teaching them to observe everything I have commanded you." This is the best way to preach, one that is followed diligently even by present-day preachers in the Church. First

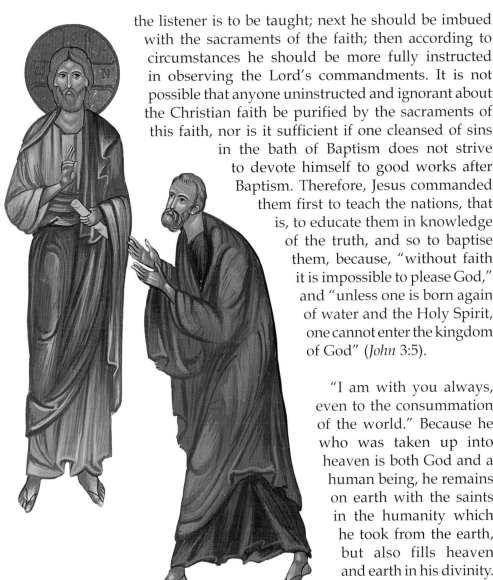

the listener is to be taught; next he should be imbued with the sacraments of the faith; then according to circumstances he should be more fully instructed in observing the Lord's commandments. It is not possible that anyone uninstructed and ignorant about the Christian faith be purified by the sacraments of this faith, nor is it sufficient if one cleansed of sins in the bath of Baptism does not strive to devote himself to good works after Baptism. Therefore, Jesus commanded them first to teach the nations, that is, to educate them in knowledge of the truth, and so to baptise them, because, "without faith it is impossible to please God," and "unless one is born again of water and the Holy Spirit, one cannot enter the kingdom of God" (*John* 3:5).

"I am with you always, even to the consummation of the world." Because he who was taken up into heaven is both God and a human being, he remains on earth with the saints in the humanity which he took from the earth, but also fills heaven and earth in his divinity. In this way he remains with us always, even to the consummation of the world. It is clear that even until the end of the age, the world will not lack those worthy of divine abiding and indwelling. Nor should we ever doubt that those struggling in this world will deserve to have Christ abiding in their hearts as a guest.

Bede the Venerable, *Homilies on the Gospels*, II, 8

The Ascension
Acts 1:4-11

> [4] While staying with them, he ordered them not to leave Jerusalem, but to wait there for the promise of the Father. "This," he said, "is what you have heard from me; [5] for John baptised with water, but you will be baptised with the Holy Spirit not many days from now." [6] So when they had come together, they asked him, "Lord, is this the time when you will restore the kingdom to Israel?" [7] He replied, "It is not for you to know the times or periods that the Father has set by his own authority. [8] But you will receive power when the Holy Spirit has come upon you; and you will be my witnesses in Jerusalem, in all Judea and Samaria, and to the ends of the earth." [9] When he had said this, as they were watching, he was lifted up, and a cloud took him out of their sight. [10] While he was going and they were gazing up toward heaven, suddenly two men in white robes stood by them. [11] They said, "Men of Galilee, why do you stand looking up toward heaven? This Jesus, who has been taken up from you into heaven, will come in the same way as you saw him go into heaven."

The Acts of the Apostles begin where the Gospel of Luke closes. Jesus instructs the disciples on the events that led to his death and resurrection as the fulfilment of God's plan, and tells them to wait in the city of Jerusalem for the gift of the Holy Spirit that will be given on the day of Pentecost. Once that has happened, they will witness to Jesus to the ends of the earth. His teaching has come to a close. The era of the Spirit and of the Church is at hand. Jesus is taken out of their sight. His journey began in Nazareth and concludes in heaven. The apostles, gazing into the sky in wonderment, are warned by two men dressed in white that they have a task ahead of them. Their journey has not come to an end. The passion, death, resurrection, and ascension of Jesus produced great joy among these founding figures. Jesus commissioned them to preach repentance and the forgiveness of sin, in Jesus' name, to the whole world (see *Luke* 24:42). Witnesses of all that has been said and done throughout the story of Jesus, they will soon be clothed with the power from on high. The journey of the disciples is about to begin. It will continue in the Church until that time when the Jesus who has ascended will return in glory.

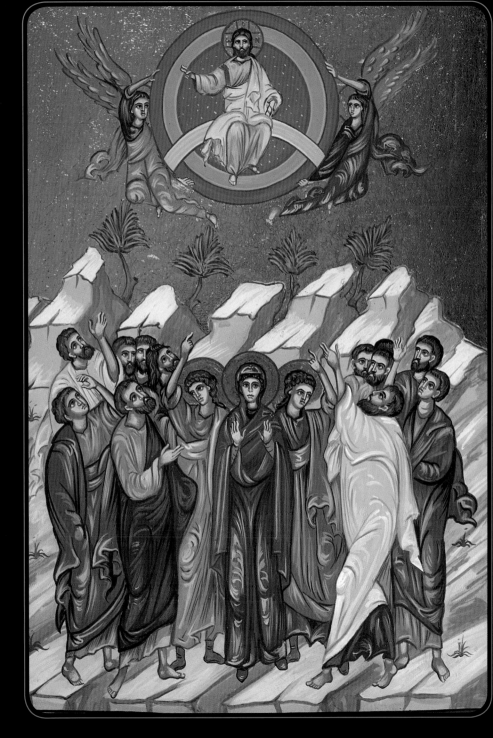

Jesus is portrayed in glory at the top of the icon. The disciples are below, with the Mother of Jesus at the centre. The mountain again appears. Jesus transcends it while the Mother of Jesus and the disciples still dwell on it. Dismay is reflected in the faces and pointing fingers of the disciples, but there is serenity on the face of Mary and acceptance in her gesture. As Mother of the disciples, she waits for her Son to return in glory.

<div align="right">Francis J. Moloney, SDB</div>

When he was about to ascend into heaven, our Lord first took care to instruct his disciples diligently concerning the mystery of faith. With this instruction they can preach it with greater certainty to the world, as they had received it from the mouth of the Truth himself, and recognised that it had long ago been foreshadowed by the words of the prophets. He said that the mysteries which Moses, the prophets and the psalms proclaimed had been fulfilled in him. Hence it is perfectly evident that the Church is one in all its saints and that the faith of all the elect is the same. All who preceded Jesus' incarnation and all who came after that time have the same faith. As we are saved through faith in his incarnation, passion and resurrection which have been accomplished, so all those that come after our time, believing in Jesus' incarnation, passion and resurrection, can hope that they will be saved through the same Author of life.

Hence it is said that the Lord, when the mysteries of his incarnation had been brought to perfection, opened the minds of his disciples so that they could understand the Scriptures. He opened their minds to understand plainly what the prophets had said obscurely.

It was opportune that the preaching of repentance and the forgiveness of sins through confession in Christ's name should have started from Jerusalem. Where the splendour of his teaching and virtues, where the triumph of his passion, where the joy of his resurrection and ascension were accomplished, there the first root of faith in him would be brought forth;

there the first shoot of the burgeoning Church, like that of some kind of great vine, would be planted. Just so, by an increase in the spreading of the word, the Church would extend the branches of her teaching into the whole world. Thus would the oracle of Isaiah be brought to fulfilment in which he said that "the law will go forth from Zion and the word of the Lord from Jerusalem, and he will judge the nations and convict the peoples" (*Isaiah* 2:3-4).

Let us then, with all devotion, dearly beloved, venerate the glory of the Lord's ascension, first expressed by the words and deeds of the prophets, later brought to fulfilment in our Mediator himself. And that we ourselves may become worthy in following in his footsteps and ascending to heaven, let us become humble on earth for our own good. Behold, we have learned in our Redeemer's ascension where all our efforts should be directed. We have recognised that the entrance to the heavenly fatherland has been opened up to human beings by the ascension into heaven of the mediator between God and human beings. Let us hurry, with all eagerness, to the perpetual bliss of this fatherland. Since we are not yet able to be there in our bodies, let us at least always dwell there in the desire of our minds.

Bede the Venerable, *Homilies on the Gospels*, II, 15

ACKNOWLEDGMENTS

Scripture references are from the New Revised Standard Version © 1989, Division of Christian Education of the National Council of Churches of Christ in the United States of America.

The following publications provided the original Greek, Syriac and Latin texts and a basis for many English translations of the Patristic passages used to comment on the icons.

Aurelii Augustini. *In Johannis Evangelium*. Corpus Christianorum Series Latina 36. Turnhout: Brepols, 1954.

Bede the Venerable. *Homilies on the Gospels: Book 2, Lent to the Dedication of the Church*. Translated by Lawrence T. Martin and David Hurst OSB. Kalamazoo: Cistercian Publications, 1991.

Cyril of Alexandria. *Commentary on John*. Translated by T. Randell. Library of the Fathers of the Church. London: Walter Smith, 1885.

Evagrius of Pontus. *The Practikos: Chapters on Prayer*. Introduction and Translation by John Eudes Bamberger OCSO. Kalamazoo: Cistercian Studies Series 4, 1981.

McCarthy, Carmel, trans. 'Saint Ephrem's Commentary on Tatian's Diatessaron' in *Journal of Semitic Studies Supplement 2*, Oxford: Oxford University Press on behalf of the University of Manchester, 1995.

Menzies, Allan, ed. *The Anti-Nicene Fathers: Translations of the Writings of the Fathers Down to A.D. 325*. 10 vols. Grand Rapids, Michigan: Wm. B. Eerdmans Publishing Company, 1978.

Migne, J.-P. ed. *Patrologiae cursus completus: Series graeca*. 162 vols. Paris, Apud Garnieri Fratres: 1857-1886.

Migne, J.-P. ed. *Patrologiae cursus completus: Series Latina*. 217 vols. Paris, Apud Garnieri Fratres: 1844-1864.

St Ambrose of Milan. *Exposition on the Holy Gospel According to Saint Luke*, Translated by Theodosia Thomkinson. 2d ed. Etna, California: Centre for Traditionalist Orthodox Studies, 2003.

St Augustine, "The Sermon on the Mount and the Harmony of the Evangelists." Volume 8 of *The Works of Aurelius Augustine. Bishop of Hippo: A New Translation*. Edited by Marcus Dods. Translated by William Findlay and S. D. F. Salmond. Edinburgh: T & T Clark, 1873.

St Augustine, *Homilies on the Gospel of John. Homilies on the First Epistle of John. Soliloquies*. Edited by Philip Schaff. The Nicene and Post-Nicene Fathers 7; Grand Rapids, Michigan: WM. B. Eerdmans Publishing Company, 1978. Reprint of 1888 edition.

St Augustine. "Sermo XXV" *Nuova Biblioteca Agostiniana* 30 (1983): 468-79

St Augustine. *Tractates on the Gospel of John 1 -10*. Translated by John. W. Rettig. The Fathers of the Church: A New Translation 78. Washington: Catholic University of America Press, 1988. Used with Permission.

St Augustine. *Tractates on the Gospel of John 11 -27*. Translated by John. W. Rettig. The Fathers of the Church: A New Translation 79. Washington: Catholic University of America Press, 1988. Used with Permission.

St Augustine. *Tractates on the Gospel of John 28 -54*. Translated by John W. Rettig. The Fathers of the Church: A New Translation 88. Washington: Catholic University of America Press, 1993. Used with Permission.

St Augustine. *Tractates on the Gospel of John 55-111*. Translated by John W. Rettig. The Fathers of the Church: A New Translation 90. Washington: Catholic University of America Press, 1994. Used with Permission.

St Augustine. *Tractates on the Gospel of John 112 -124*. Translated by John W. Rettig. The Fathers of the Church: A New Translation 92. Washington: Catholic University of America Press, 1995. Used with Permission.

St Ephrem. *Hymns on Paradise*. Introduction and Translation by Sebastian Brock. New York: St Vladimir's Seminary Press, 1990. Used with Permission.

St Hilary of Poitiers. *The Trinity*. Translated by Stephen McKenna CSsR. The Fathers of the Church: A New Translation 25. Washington: Catholic University of America Press, 1954.

St Jerome. *The Homilies of St Jerome: Volume 2 (Homilies 60-96)*. Translated by Sister Marie Liguori Ewald IHM. The Fathers of the Church: A New Translation 57. Washington: Catholic University of America Press, 1966. Used with Permission.

St Leo the Great. *Sermons*. Translated by Jane Patricia Feeland CSJB and Agnes Josephine Conway SSJ. The Fathers of the Church: A New Translation 93. Washington: Catholic University of America Press, 1996. Used with Permission.

St Peter Chrysologus, *Selected Sermons: Volume 2*. Translated by William B. Palardy. The Fathers of the Church: A New Translation 109. Washington: Catholic University of America Press, 2004. Used with Permission.